11/14

IMAGES
of America

LITCHFIELD

IMAGES
of America

LITCHFIELD

Welcome to Litchfield !

Ralph White

Ralph White

ARCADIA
PUBLISHING

Published by Arcadia Publishing
Charleston, South Carolina

Printed in the United States of America

Library of Congress Control Number: 2010940861

For all general information, please contact Arcadia Publishing:
Telephone 843-853-2070
Fax 843-853-0044
E-mail sales@arcadiapublishing.com
For customer service and orders:
Toll-Free 1-888-313-2665

Visit us on the Internet at www.arcadiapublishing.com

To Alain Campbell White and Margaret "May" Whitlock White

CONTENTS

ACKNOWLEDGMENTS

The author acknowledges, with deep gratitude, the assistance of the White Memorial Foundation, the Van Winkle Family Archives, Cleve Fuessenich, Joyce Cropsey, John Fahey, Daniel Keefe, Perley Grimes, Kenneth Merz, Peter Tillou, Connecticut Department of Environmental Protection—Topsmead State Forest, Connecticut State Library, Litchfield Historical Society, Greater Litchfield Preservation Trust, Peter Onderdonk, Litchfield Country Club, Leroy F. Roberts, Marian Ellis, Walter D. France, Carol Bramley, The Sanctum, Oren Boynton, Dr. Frank Vanoni, Kay Carroll, Walter Mack, "Rosie" Furniss, Laurel Galloway, Richard Wurts, Fred Parkin, the Business Center, and Hastings House/Daytrips Publishers.

All images are from the author's collection unless otherwise noted.

INTRODUCTION

From its earliest days, Litchfield has always held an exceptional attraction. For the Indians, it was the prime hunting and fishing grounds. Indeed, even after they sold what the early settlers called the Western Lands, the Indians kept an area around Mount Tom for their use. For the settlers, mainly from Windsor and Hartford, Litchfield's very remoteness and its cool upland climate and uncut timberlands must have looked heavenly. But ask a Litchfield resident today how Litchfield became so exceptional and the likely response is a shrug. We know we are a little different, a little greener, cooler, more educated, and affluent. We have become so accustomed to Litchfield's exceptionalism that when we foray out into the world, we wonder why other towns do not have similarly stunning architecture, tree-lined boulevards, natural beauty, and reverence for history.

Historians refer to the years between 1784 and 1834 as Litchfield's Golden Age, for it was during this 50-year period that Tapping Reeve's Litchfield Law School and Sarah Pierce's Litchfield Female Academy flourished. These institutions were to have a demographic impact beyond their educational objectives in that they attracted to Litchfield some of the best and the brightest then living in the freshly liberated republic. But what happened in the years following 1834 to end Litchfield's Golden Age?

Ironically, Litchfield's exceptionalism derived as much from what it lacked as for what it possessed. And what Litchfield lacked (with the exception of Bantam Falls) was a swiftly flowing river. Without water to power mills, Litchfield was bypassed by the Industrial Revolution. Without mills, there was no surge of laborers into Litchfield as there was in towns in the valleys. With neither mills nor population, Litchfield was largely bypassed by the railroad industry, which favored lowland routes. In an era when progress was defined by the language of economics, Litchfield slipped off the grid. Indeed, it was Litchfield's very aloofness toward progress that preserved its colonial-era demographics. Litchfield has always had an eye for the past, and it has always taken its stewardship of American history seriously.

In 1913, a brother and sister with remarkable vision and generosity seized a fleeting opportunity to add a legacy of natural conservation to Litchfield's already impressive curriculum vitae. Alain Campbell White and Margaret "May" White saw the depredations of development destroying the natural world around them and determined to stop it in its tracks. The foundation that they created now comprises the 4,000 acres of the White Memorial Conservation Center. Without White Memorial, Litchfield would be a very different town.

Today, Litchfield preserves history and nature with equal passion. Perhaps this exceptional town can be forgiven for thinking of itself as having entered another Golden Age.

Many early-20th-century photographs of Litchfield are the work of the Karl brothers. Imagine one of these brothers hunched under the light-cancelling shawl of a bulky, early camera perched on a sturdy tripod. After carefully oxidizing the inverted image into a thin deposition of sliver on a fragile glass plate, the negatives would go by ship to Germany for printing. The best of these

shadowy black and white images would be printed into postcards and then returned by ship back across the Atlantic. Remarkably, the Karl brothers postcard on the top of page 105 made the transatlantic trip a second time, when it was mailed from Litchfield to an address in England, and eventually returned again to the author's collection 100 years later. Karl Street, off East Street, recognizes these pioneers in photography.

This book is organized geographically to enable the imagination to better fix the location where the vintage photographs were taken. They show homes, streets, landscapes, and people as they once were, and just as the original people are long gone, the same is true of many of the buildings featured here. Gone are the old Litchfield High School, the Casino, Phelps Tavern, the Litchfield Female Academy, the Berkshire Hotel, and the church were Lyman Beecher preached. But, thankfully, Litchfield's preservationist ethic has always run strong, and many historic buildings have been restored.

The book opens with vintage images of the village green and the buildings that surround it, or once did. The second section escorts the reader's imagination up the east side of North Street and down the west side, past some of the grand old homes for which Litchfield is renowned. There is also a brief excursion down Prospect Street. Close-up images show architectural detail that might otherwise escape observation.

South Street beckons on the far side of the village green, where the first American law school and several Revolutionary-era homes are located. Here are also the homes of two early governors of Connecticut as well as the birthplace of one of the foremost heroes of the Revolutionary War, Ethan Allen.

The path back up South Street brings history sharply into focus with the home of Oliver Wolcott, a signer of the Declaration of Independence. Signing that document branded him as a traitor to England and condemned him to death if the war were lost. And everyone knew where he lived.

Returning to town, the Phineas Minor House, now the clubhouse of The Sanctum is on the right. Photographs show these playful gentlemen at their 1909 and 1910 summer picnics, playing billiards inside the clubhouse, and motoring around in a horseless carriage. The Episcopal and Catholic churches depicted on South Street are relatively new, as fire destroyed one and the other was relocated. The Congregational Church was deconsecrated, relocated, moved back, and reconsecrated. Historic architecture is not solely the province of Litchfield's main streets. As this book will show, it can be found in side streets all over this exceptional village.

Just as Litchfield is more than its historic district, it is also more than just one town. It is actually eight towns, and it is remarkable how much there is to see within a few minutes' drive to Bantam, Milton, Northfield, East Litchfield, Goshen, Warren, and Morris. Photographers have been training their lenses on Bantam Lake and Bantam River since photography was invented, and this book features several vintage waterscapes.

This book's tour of historic Litchfield concludes at the White Memorial Conservation Center, where opportunities for exploration are endless. It can be visited on horseback, by canoe, on a mountain bike, or the old-fashioned way—on foot. This book depicts White's Woods as it existed during Alain and May White's lifetimes. Indeed, many photographs are from their own family albums, courtesy of the White Memorial Foundation.

One

AROUND THE GREEN

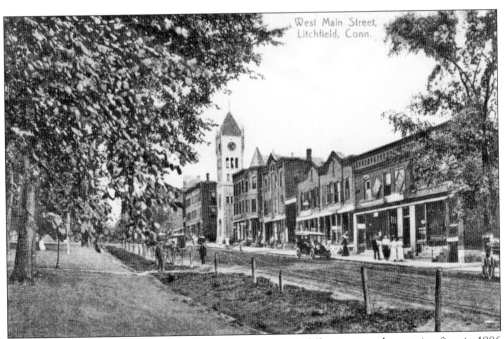

West Main Street, Litchfield, Conn.

Brick and granite became the preferred building materials following two devastating fires in 1886 and 1888, and they have been the commercial district's dominant hues ever since. This photograph depicts an age when horse-drawn and horseless carriages coexisted side by side.

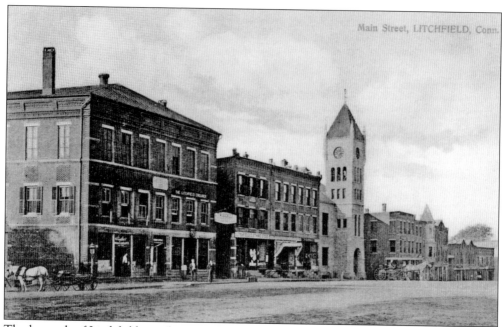

The borough of Litchfield was designated as the Old and Historic District of Litchfield by the Connecticut State Legislature, the first such designation in the state. By the terms of the act, local controls have been provided to ensure that no changes may be made that are visible from the streets unless they harmonize with existing structures. The commercial district was rebuilt immediately following the fire of 1888 as these construction dates attest: starting from the corner, Phelps Block, 1888; Bishop Block, 1888; Pratt Block, 1886; courthouse, 1889; Meafoy's Block, 1890; Sanford Block, 1890; Sedgwick Block, 1889; Beach Block, 1890; Granniss and Elmore Block, 1888; Marcy Block, 1887; and the Ives Block, 1905. (Above, courtesy of Daniel Keefe collection.)

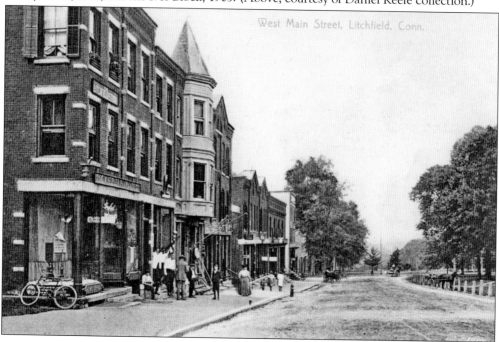

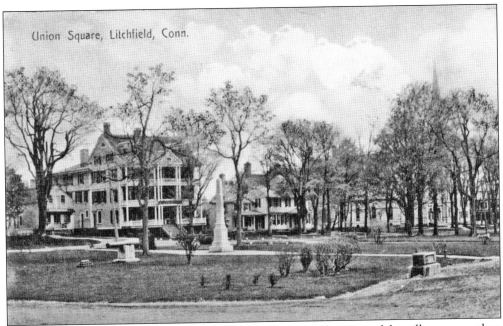

This 1907 photograph by the Karl brothers depicts the central section of the village green, then known as Union Square. This section was also referred to as Shrubbery Park and Central Park. It includes Litchfield's war memorials and the town's trademark Civil War cannon. North and South Streets are not aligned due to marshes that existed when the town was founded.

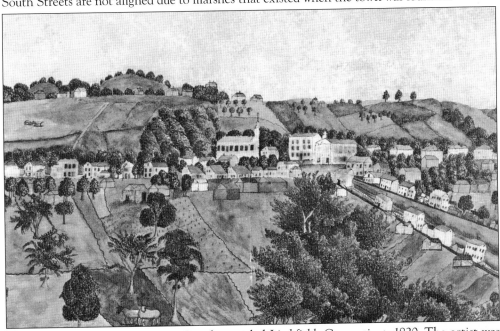

This painting, by artist Rebecca Couch, is titled *Litchfield, Connecticut, 1820*. The artist was born in 1788 in Redding, Connecticut, and died there in 1863. She spent most of her life in Lansingburgh, New York, and lived in Litchfield only briefly. It is tempting to speculate that this painting was done from memory during the period she was away since the topography seems fanciful. (Photograph by George Copeland Boswell; courtesy of Daniel Keefe collection.)

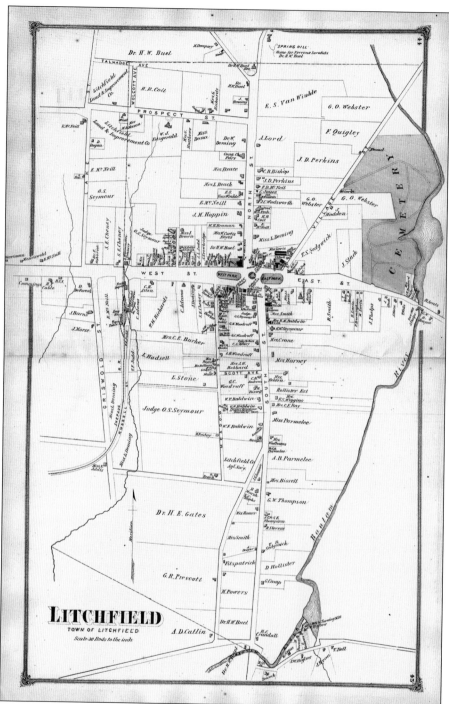

This map was published in 1874 by F.W. Beers, of 36 Vesey Street, New York. It clearly shows the three segments of the village green and the layout of streets, which have changed very little. Torrington Road was called Village Street. Each house bears its owner's name. Many of these names would have been familiar to the town's founders, and many of them are familiar to the town's current residents. Many of the homes identified on this map are featured in this book.

12

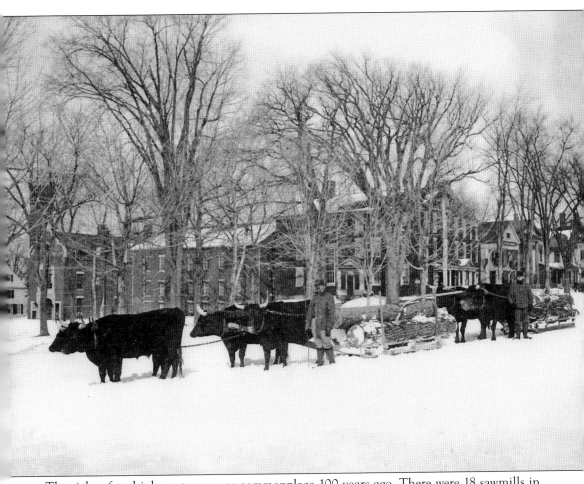

The sight of multiple ox teams was commonplace 100 years ago. There were 18 sawmills in Litchfield in 1800, and only ox teams yoked to snow sledges could transport the largest tree trunks to the mills. These logs were likely destined for the Biglow sawmill pictured on page 83. This photograph also shows the Litchfield County Jail on the corner of North and West Streets. The Dr. William Deming House, 1877, now Rose Haven, is in the distance to the right, and the Eli Smith House, 1780, now the Cramer and Anderson law firm, is visible on the far left. The old Rexall Drugstore is visible between the bank and the jail. The huge Whipping Post Elm is visible at the corner of the jail. (Courtesy of Daniel Keefe collection.)

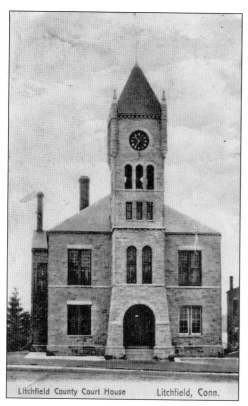

Litchfield County Court House Litchfield, Conn.

The Litchfield Courthouse is the town's most iconic image, but it has not always looked as it does today. The courthouse, built of Roxbury granite in the Romanesque Revival style, owes its curious styling to its 1913–1914 Colonial Revival remodeling. The throwback renovation of this prominent building more aptly reflects the colonial character of the town. The alterations were limited to the exterior leaving the interior much as it was, with its marbleized Eastlake mantels and large courtroom on the second level.

Litchfield County Court House, Litchfield, Conn.

The original courthouse was located on the West Park and was a small wooden building known for an outsized fireplace. It was replaced by another wooden courthouse in the present location, from plans by William Spratt. It featured a colonnaded porch and a very tall spire (see page 69, top photograph). It was destroyed by the fire of 1886, and its replacement was also destroyed by fire two years later in a conflagration that wiped out most of the commercial district. After two successive fires, granite was a logical choice for the courthouse. It was designed by Waterbury architect Robert Wakeman Hill and completed in 1889. As Litchfield embraced the Colonial Revival movement, the courthouse was remodeled in 1914 to reflect the colonial character of the town. Georgian-style corner quoins were added to the structure, and the original turreted tower was replaced with a new cupola. The clock tower houses a Seth Thomas clock, manufactured in nearby Thomaston.

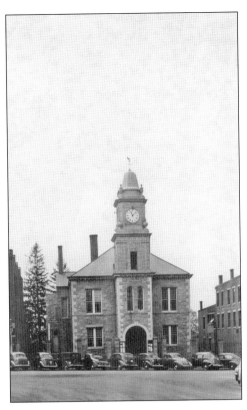

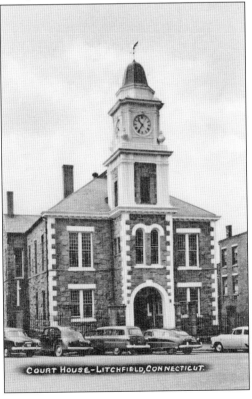

COURT HOUSE–LITCHFIELD, CONNECTICUT.

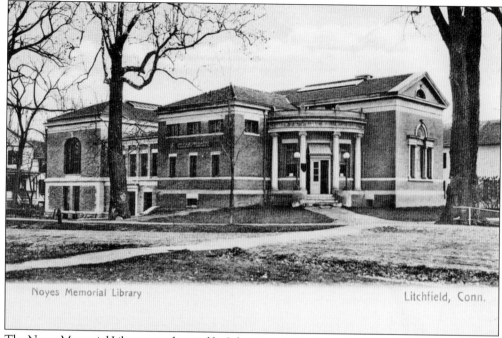

Noyes Memorial Library Litchfield, Conn.

The Noyes Memorial Library was donated by John Arendt Vanderpoel in memory of Julia Tallmadge Noyes. The dramatic stained glass window in the Reading Room is a memorial to John Vanderpoel from his wife. This building now houses the Litchfield Historical Society.

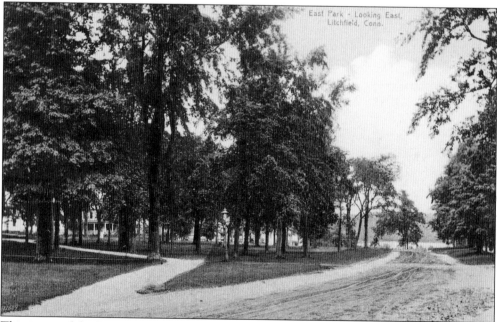

East Park - Looking East, Litchfield, Conn.

This image of the East Park may be dated by the Reuben Merriman House, visible through the trees, which was relocated in 1917. The Litchfield High School can also be identified; it was destroyed about 1920. The lamppost in the center has a gas light. (Courtesy of the Van Winkle Family Archives.)

The present First Congregational Church is the third meetinghouse of the First Ecclesiastical Society of Litchfield and was built in 1829. Its design is attributed to architect Levi Newell of Southington. Many of Litchfield's imposing elm trees, long ago felled by disease, were planted by Tapping Reeve law student and future vice president John Caldwell Calhoun. The congregation was initially gathered in 1721 as the United Church of Christ. (Courtesy of Hastings House/Daytrips Publishers.)

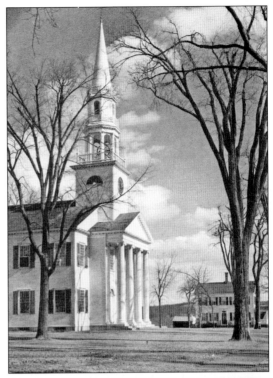

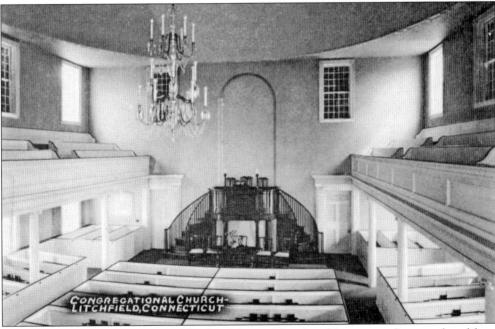

During its final relocation, in 1930, the door of one of this church's pews was discovered, and from it the type and pew size were determined. The pulpit was reconstructed entirely from sketches drawn from memory by former parishioners. The two lamps are from the second church. The chandelier was reproduced in Boston, and the two lamps in the vestibule saw earlier use in an English church.

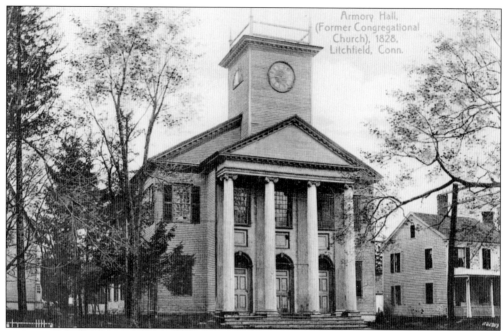

This is the First Congregational Church during its 57-year deconsecrated phase, from 1873 to 1930. During this time, it was moved around the corner to face Torrington Road and it served as a dance hall, movie house, bowling alley, and armory. But parishioners were fond of the old church, and they returned it to its present location. (Courtesy of the Van Winkle Family Archives.)

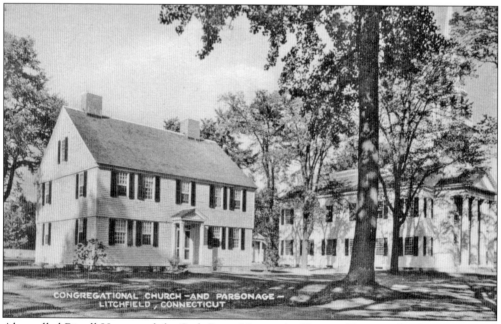

Also called Bissell House and the Seth Beers House, the Skinner House is the Congregational parsonage and was built in 1761 by Gen. Timothy Skinner. This building, with its double overhang, was meticulously restored in 1949 and moved back from the street to a position in harmony with the church. (Courtesy of Richard Wurts.)

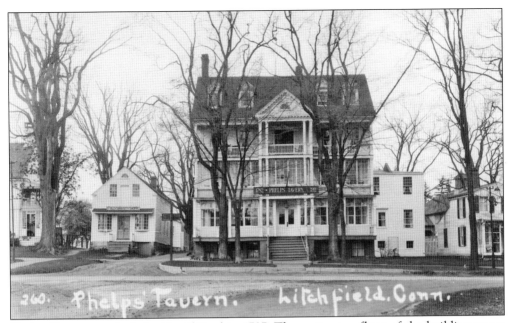

Phelps Tavern was built by David Buel in 1787. The entire top floor of the building was a ballroom and was used for all types of functions, including student balls, theatrical performances, Independence Day dinners, and a welcome dinner for the Comte de Lafayette in 1824. It was demolished in 1935.

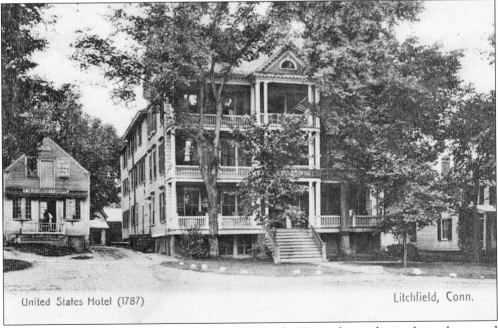

United States Hotel (1787) Litchfield, Conn.

In the 1860s, the Phelps Tavern was purchased by Rufus King, who modernized it and renamed it the United States Hotel. When Eugene L. Phelps purchased it from King in 1911, he renamed it the Phelps Tavern. The third floor Assembly Room had a balcony for musicians and a red-cushioned divan surrounding the room.

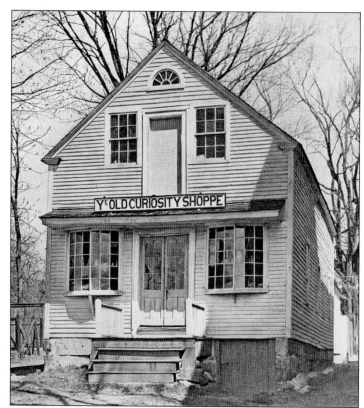

Dr. Ruben Smith constructed this quaint building on North Street in 1781 and used it as an apothecary shop and office. It was relocated to this site in 1812 by Luke Lewis. Some old photographs show it as Ye Old Curiosity Shoppe. The word "ye" was a contraction of "the," to reduce typesetters' labor, and was always pronounced "the."

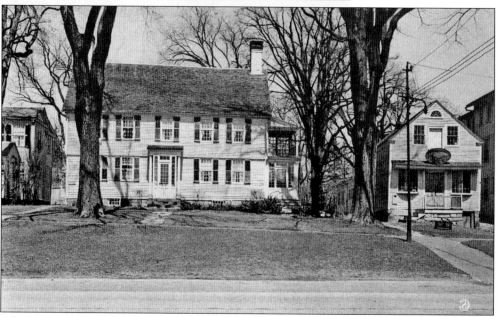

John Collins, the son of the first pastor of the United Church of Christ, completed construction of this house in 1782. It has an enormous kitchen fireplace and oven, and it once served as an inn. The first meeting of the Freemasons in Litchfield was held in this home on June 13, 1781. (Courtesy of the Van Winkle Family Archives.)

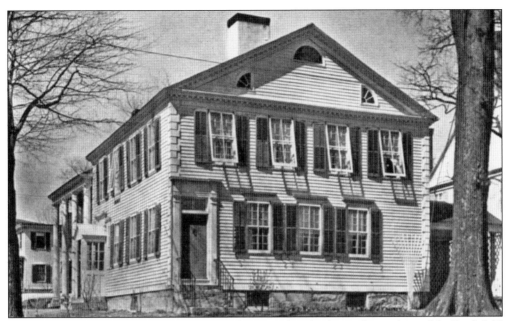

The Butler House, or Corner House, was built in 1781 by Charles Butler, cashier of the Litchfield Bank, on land originally granted to the Reverend Timothy Collins. This home became renowned in 1806 as housing a collection of large-as-life wax figures. (Courtesy of White Pine Bureau.)

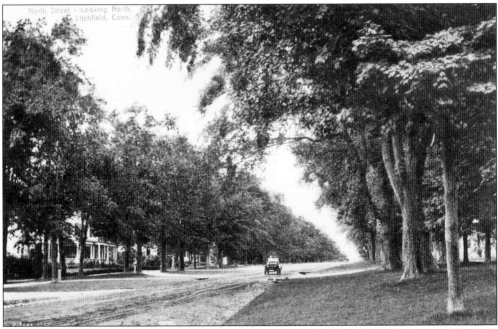

The first horseless carriages made their appearance in Litchfield in the early years of the 20th century. Chauffeurs were indispensable to crank-start the engines and to repair flat tires, which were quite common. Rows of elms gave North Street a stately elegance. (Courtesy of the Van Winkle Family Archives.)

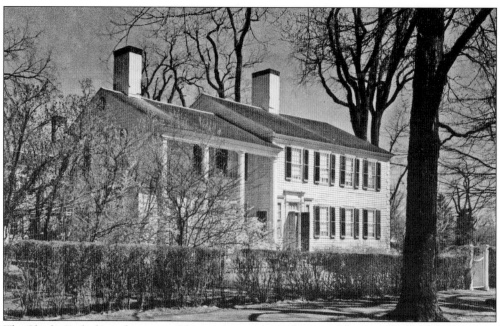

The Charles Butler house has some of the most interesting architectural detail in all of Litchfield, starting with the two-story porch with its imposing pillars, added by Frederick Deming, son of Julius Deming. The detail around the doorways is elegant. (Courtesy of Hastings House/Daytrips Publishers.)

Part of the enduring charm of the Butler House is its remarkable exterior detail. This book includes photographs of two of its doorways (here and on page 21). Wanderers around Litchfield are well advised to stop to admire the exterior architectural detail apparent in many of Litchfield's oldest homes. The homes themselves are works of art. (Courtesy of Hastings House/Daytrips Publishers.)

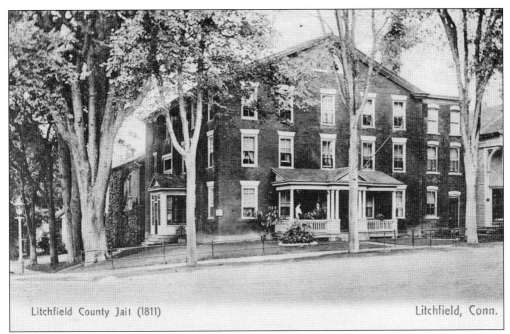

Litchfield County Jail (1811) Litchfield, Conn.

This brick jail was erected in 1811 at the intersection of North and West Streets. The above photograph of the east facade shows the monstrous elm on the corner of North and West Streets known as the "Whipping Post Elm," where public floggings were carried out. It attained a circumference of 150 inches before it died at age 200. The absence of bars on the front windows is explained by the jail cells being located on the interior of the building. The photograph below shows the jail's south facade. There is a tunnel from the basement of the jail to the basement of one of the buildings on the far side of the green, and legend has it that one prisoner broke out of jail to go to a tavern, then broke back in to go to bed.

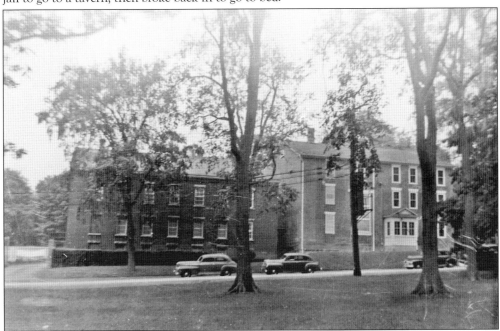

West Street Litchfield, Conn.

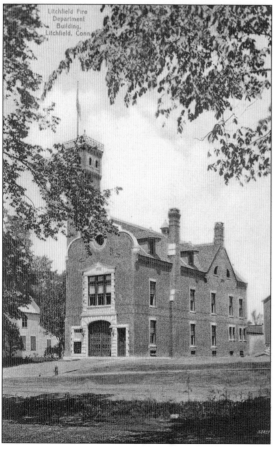

Litchfield Fire
Department
Building,
Litchfield, Conn.

The Litchfield Firehouse, adjacent to the jail, was built in 1895 with a donation from Julius Deming Perkins, son of Clarissa Deming Perkins (pictured on page 30). The disastrous fires of 1886 and 1988 convinced Litchfield's residents of the need for a fully equipped and well-organized firehouse. Perkins likely engaged E.K. Rossiter as the architect, since he had worked with him on other projects, including his own home. This striking brick firehouse was all the more remarkable for having a gentlemen's club on the second floor, accessed by a back stairwell. The photograph at left shows the tower at the southwest corner of the firehouse used for hanging fire hoses up to dry. The outline of this tower is still visible on the west side of the building. (Both, courtesy of the Daniel Keefe collection; text courtesy of the Litchfield Historical Society.)

Two

NORTH STREET

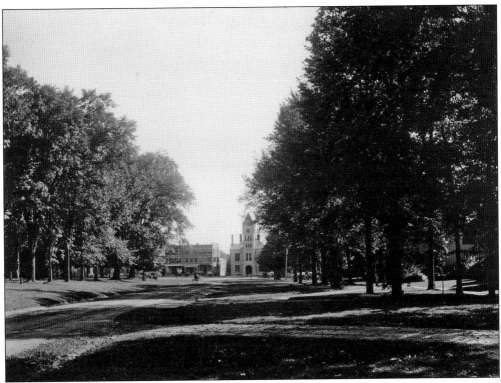

North Street leaves an impression like no other street in America. Other Revolutionary-era towns might have two or three historic homes scattered over several square miles. But a quarter-mile stroll up North Street's eastern sidewalk and a return stroll along the western one showcases many historically significant homes over 200 years old. (Courtesy White Memorial Foundation.)

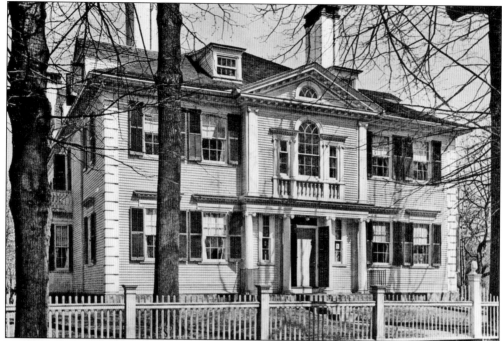

Prosperous merchant Julius Deming built this beautiful house in 1793. Both Benjamin Tallmadge and Oliver Wolcott Jr. were partners in Deming's business, the Litchfield China Trading Company. The house was designed by architect William Spratt, whose work also included the original courthouse and Sheldon Tavern. The refinement of architectural detail, particularly the portico and Palladian windows, is remarkable even by Litchfield standards. Early maps show the extent of the gardens in the rear of this property (below), and they have largely been preserved into the modern era. (Courtesy White Pine Board.)

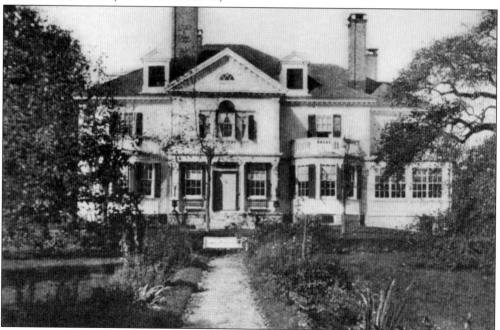

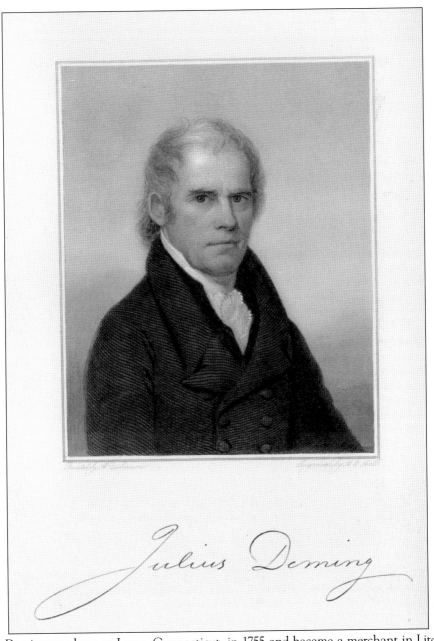

Julius Deming

Julius Deming was born at Lyme, Connecticut, in 1755 and became a merchant in Litchfield in 1781. He was a man of remarkable energy and enterprise. Soon after settling here he visited London and made arrangements to have his goods imported directly from that city to Litchfield, very unusual for a country merchant in New England at that time. Deming, Colonel Tallmadge, and Oliver Wolcott purchased the ship *Trident* and opened trade with China, operating under the name of the Litchfield China Trading Company. Deming became known as "Crowbar Justice" while serving as county magistrate. He was active in the United Church of Christ, now the First Congregational Church, and the silver communion cups still in use there were gifts from him. Deming imported 200 horses from Europe to improve the stock of his American horses. (Courtesy of Payne Kenyon Kilbourne.)

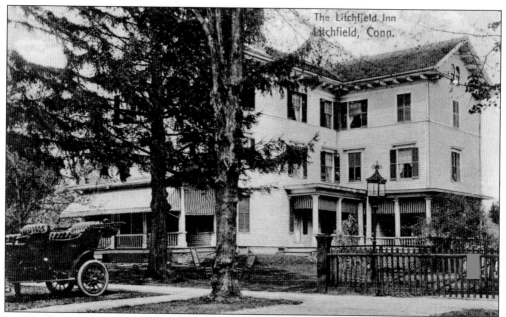

Built by Edwin McNeil in 1867, this is a good example of an older home that was redesigned in the Colonial Revival era. McNeil was a civil engineer and served as a major in the Civil War, and he is credited with bringing the Shepaug Railroad to Litchfield. In the early 20th century, the house operated as the Litchfield Inn. (Courtesy of Kenneth Merz.)

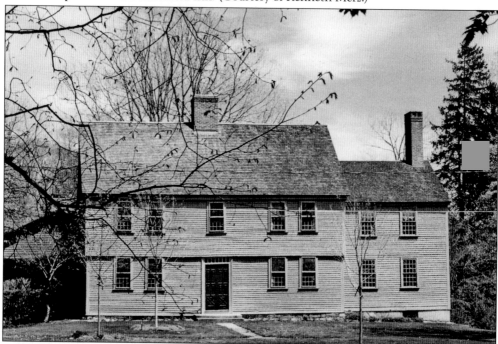

Dr. Reuben Smith built this classic colonial in 1770. The south wing was added as a law office in 1806 by Asa Bacon, a graduate of Tapping Reeve's law school. This house has benefitted from continuing, historically accurate restoration programs by successive owners. (Courtesy of Daniel Keefe.)

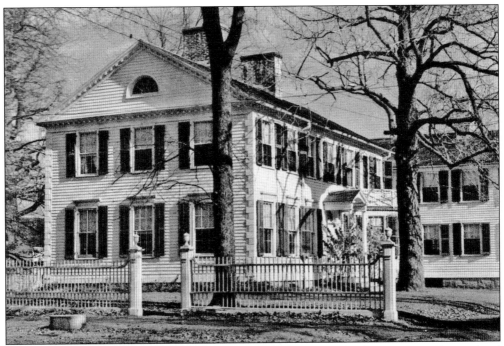

Built by Leonard Goodwin in 1828, this home on North Street is unique because its pedimented end faces the street and its entrance faces the warm southern sun. This home's exceptional attention to historic detail extends even to the picket fence. (Courtesy Hastings House/Daytrips Publishers.)

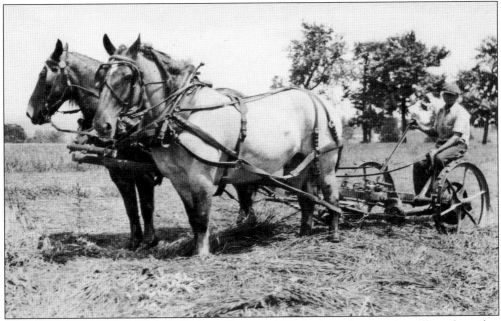

This photograph, taken by Edith Morton Chase in 1933, depicts a farm worker tilling the soil at Topsmead. Motorized tractors were common by this time, and Edith Chase could certainly afford one, but this magnificent draft horse team needed employment. (Courtesy of Connecticut DEP, Topsmead State Forest.)

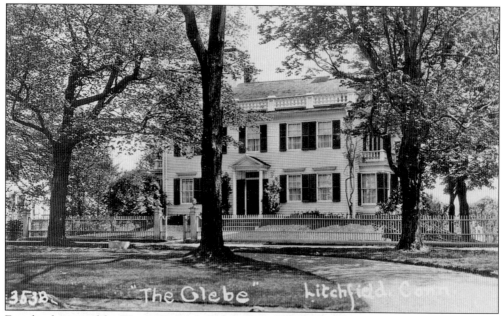

Farmland reserved for Congregational pastors was referred to as the Glebe. A house built on that land was called Glebe House. In 1833, Julius Deming purchased this house from the Reverend Judah Champion and gave it to his daughter Clarissa (seen below), who married Charles Perkins and raised her family here. (Courtesy Dr. Frank Vanoni.)

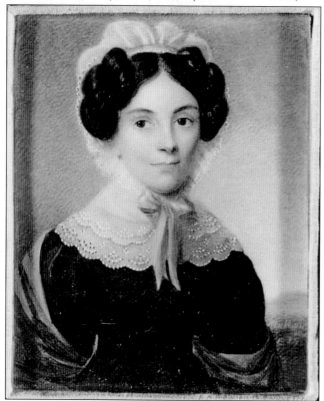

Clarissa Deming Perkins followed the fashion that, until the age of 40, ladies wore their coiffure in three puffs on either side of the face. She was devoutly religious and devoted to foreign missions. In her parlor always stood a large chest to be filled with garments to be sent to the Hawaiian Islands. She had eight children. (Photograph of painting by Anson Dickinson; courtesy of Dr. Frank Vanoni, from the Collection of the Litchfield Historical Society.)

Thomas and Catherine Trowbridge built this Victorian home in 1876, and it was remodeled in 1940 in the Colonial Revival style by owner Franklin Coe. As with any such transformation, the remodeling eliminated nearly all of the original design features. (Photograph by Charles E. Morgan; courtesy Frank B. Eraclito, Jr.)

This stunning cedar shingle Victorian, called Meadowhome, once anchored the northern end of North Street, where the Forman School's French chateau now stands. It was built in 1900 by McKim, Mead, and White for Mary DuBois and Hanna Louise Van Winkle, sisters of Edgar Beach Van Winkle. (Courtesy of the Van Winkle Family Archives.)

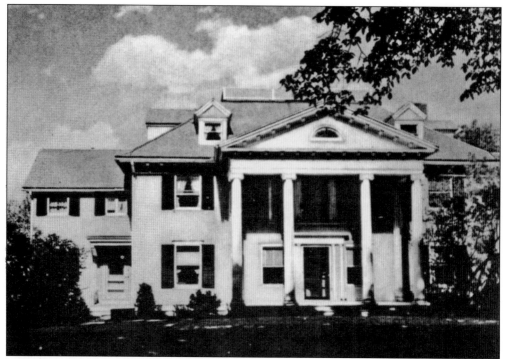

The John L. Buel House is now part of the school that John and Julie Forman founded for children with learning differences. Albert Einstein, who Forman knew from Princeton and who faced reading challenges of his own, was on Forman's board and helped draft the school's groundbreaking curriculum. (Photograph by Alice T. Bulkeley; courtesy of the *Hartford Press*.)

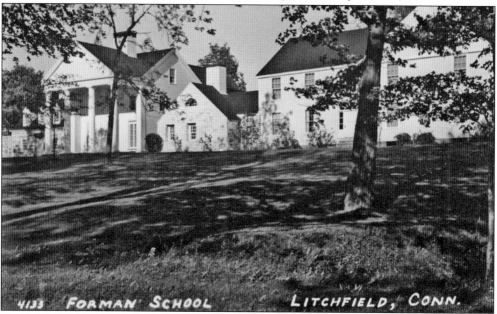

Now part of Forman School, this campus is labeled Spring Hill Home for Nervous Invalids on old maps of Litchfield. Upon the death of her husband, Julie Forman turned to her brother S. Dillon Ripley, then secretary of the Smithsonian Institution, to chair the school's Board of Trustees.

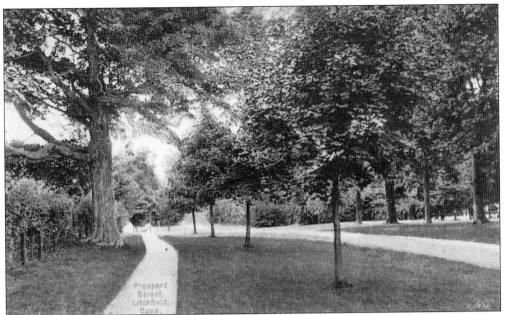

This photograph shows a still unpaved Prospect Street, looking east toward the intersection with North Street. The fence on the left is still there. On the other side of that fence would be the "Beecher Elm" and "Beecher Well" and the family home of Harriet Beecher Stowe. Newly planted maples line the street. (Courtesy of the Van Winkle Family Archives.)

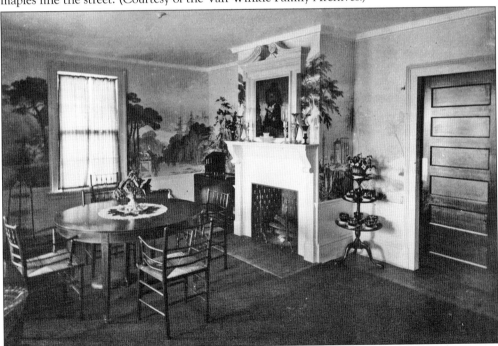

This photograph shows the dining room of Mary Perkins Quincy in her 1904 Prospect Street home. She was the granddaughter of Clarissa Deming Perkins and the great-granddaughter of Julius Deming. The mural on the far wall recalls the family's China-trading background. (Courtesy of White Memorial Foundation.)

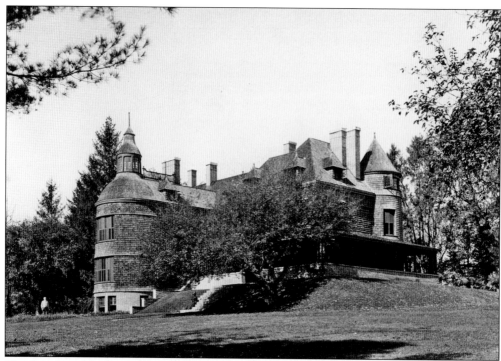

This house made one of the most dramatic architectural metamorphoses of any in Litchfield. It was originally built for William and Mary Ann Fitzgerald, in 1886, as a cedar shingle Victorian. But in 1928, the Fitzgeralds had a change of heart and rebuilt it from scratch. According to Litchfield's archives, "The remodeling ranks as one of the most dramatic Colonial Revivalizations of an earlier house in the Borough, and illustrates to what lengths devotees of the revival mode would go to confirm to the colonial character of the village." Following its remodeling, the house was purchased by Charles Hickox, an admiralty lawyer from New York, and his wife, Lydia. The transformation, shown at the bottom of page 35, is scarcely believable. (Above, courtesy of White Memorial Foundation; below, courtesy of Peter Tillou.)

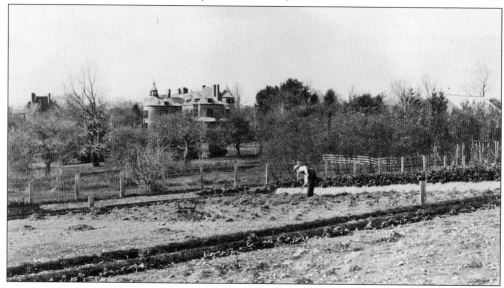

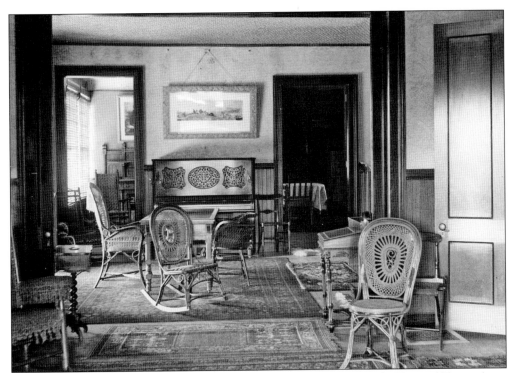

This photograph, taken in 1909 by Alain White, shows a small room in the Fitzgerald house (seen on opposite page). The simple room has many features that might have attracted White's attention, including the filigreed woodwork on the piano, the elegant secretary, the finely worked wicker furniture, and the expanses of Oriental carpets. (Courtesy of White Memorial Foundation.)

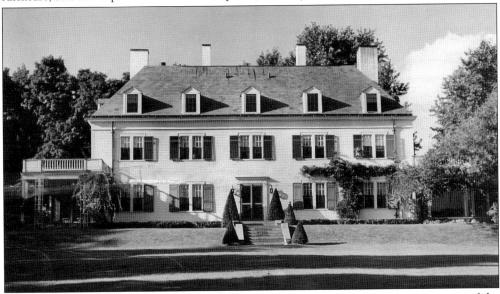

The garden side of the Fitzgerald-Hickox house is as dramatic as the front. A comparison of the chimneys in this photograph and those in the house shown on page 34 shows that it is, indeed, the same building. Now one of the grandest of the Colonial Revival homes in Litchfield, it was once one of the grandest Victorian houses. (Courtesy of Peter Tillou.)

A Litchfield resident, Harriet Beecher Stowe added a poignant voice to the deluge of political antislavery discourse with her novel *Uncle Tom's Cabin*. "On the shores of our free states are emerging the poor, shattered, broken remnants of families, . . . men and women, escaped by miraculous providences from the scourges of slavery . . . a system which confounds and confuses every principle of Christianity and morality. They come to seek a refuge among you; they come to seek education, knowledge, Christianity. What do you owe to these poor, unfortunates, O Christians? Does not every American Christian owe to the African race some effort at reparation for the wrongs that the American nation has brought upon them?"

The Beecher Well (Site of Beecher Homestead) Litchfield, Conn.

An elm, no longer standing, at the northwest corner of North Street and Prospect Street became known as the "Beecher Elm," for it was on this site that Lyman Beecher lived and where his famous children Henry Ward Beecher and Harriet Beecher Stowe were born. The Beechers' well house still exists on this property.

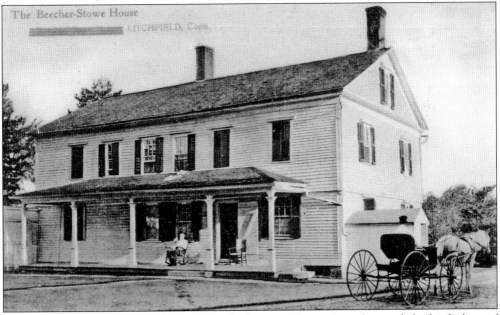

This house, built in 1775 for $1,350, was the home of Lyman Beecher and the birthplace of Henry Ward Beecher and Harriet Beecher Stowe. It was relocated to the campus of the Forman School where it served as a dormitory. The house was ultimately purchased, disassembled, and its components put into storage by a group of civic-minded investors who were dedicated to its preservation.

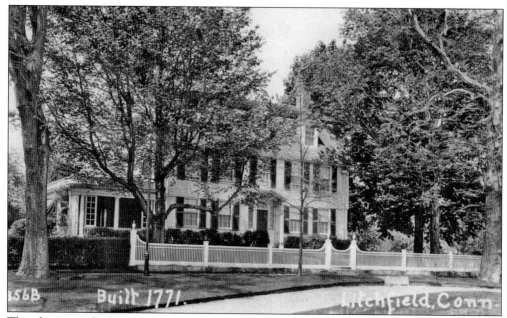

This classic, gambrel-roof house was built in 1776 by Lynde Lord, an ensign in the last French War and the last high sheriff of Litchfield County in pre-Revolutionary years. The house preserves delicate 18th-century architectural details, including the slim double pillars flanking the portico. The south wing is a later addition. The date on this photograph is inaccurate.

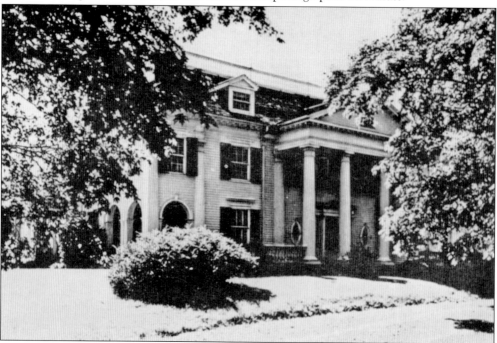

The Underwood House is more historically significant as the location where, in 1792, Sarah Pierce opened a school dedicated to education of women. Initially, Pierce provided lessons in her own dining room. When she moved the lessons into a separate building, it became the Litchfield Female Academy. (Photograph by Charles E. Morgan; courtesy of Frank B. Eraclito, Jr.)

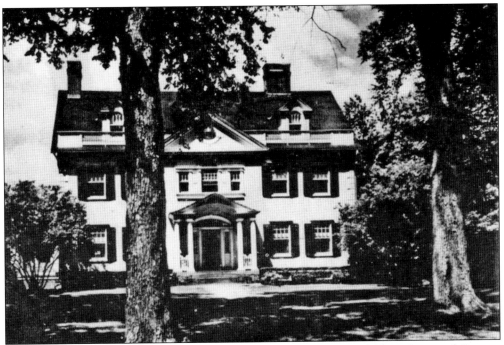

Pictured is the Henry Sabin Chase House. Chase was the president of Chase Brass and Copper, in Waterbury. He was also the father of Edith Morton Chase, whose home, Topsmead, is featured in this book. (Photograph by Charles E. Morgan; courtesy of Frank B. Eraclito Jr.)

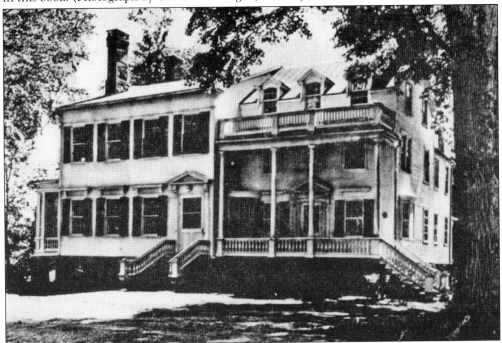

So tall that he was nicknamed "the Giant," John Allen built this house in 1797, and the oversized doorways in this home are considered testimony to his size. Allen was a prominent attorney and congressman. (Photograph by Charles E. Morgan; courtesy of Frank B. Eraclito Jr.)

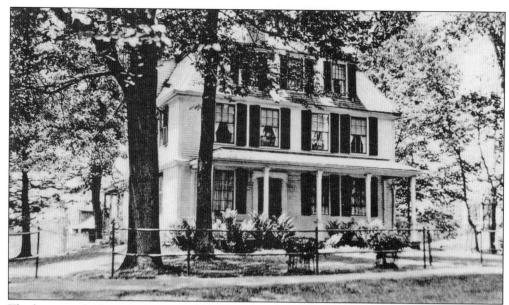

This house was built in 1785 by prominent physician Dr. Daniel Sheldon, no relation to the innkeeping Sheltons three houses to the south. Dr. Shelton maintained an office in the northwestern corner of the house. Many of the students of Sarah Pierce's Litchfield Female Academy boarded here.

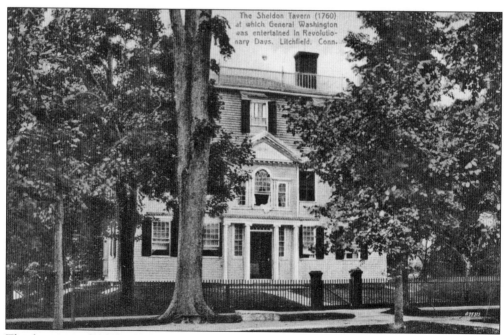

This house was built by Elisha Sheldon, a member of the Governor's Council, in 1760. His son Samuel Sheldon turned the building into an inn. Gen. George Washington's diary mentions his staying here, in the northeast bedroom. This house sometimes appears as the Gould House, since it was once the home of Tapping Reeve associate James Gould.

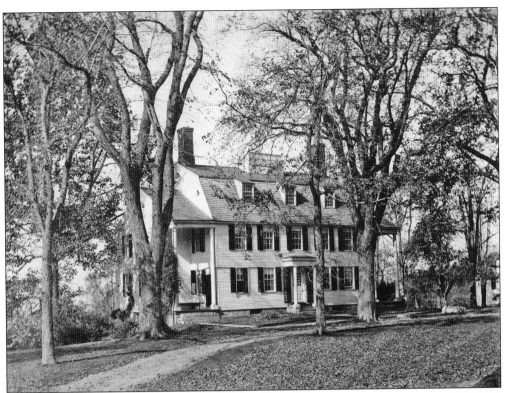

Built in 1775 by Thomas Sheldon, this was the home of Col. Benjamin Tallmadge. After a visit to Mount Vernon to visit George Washington, Tallmadge added the north and south porticos with their imposing columns. Tallmadge was also a friend of fellow patriot Nathan Hale, whom he had met as a student at Yale. It was Tallmadge who uncovered the treason of Benedict Arnold and who held his accomplice, Major Andre, in custody in this house pending his execution. Benjamin Franklin's son William, who was a Royalist, was also detained nearby. Following independence, Tallmadge represented Connecticut in the US Congress for 16 years. (Above, courtesy of White Memorial Foundation; right, drawing from Payne Kenyon Kilbourne; courtesy Daniel Keefe Collection.)

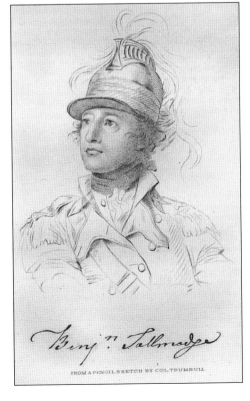

The First National Bank, built in 1815, was originally a branch of the Phoenix Bank of Hartford. Local Federalist leaders in the post-Revolutionary years had promoted the establishment of a bank in Litchfield, and one of their most prominent members, Benjamin Tallmadge, became its first president. The bank was reincorporated in 1864 as the First National Bank. It is the sixth oldest bank in the state of Connecticut and has operated continuously for nearly 200 years. Conventional wisdom has it that this is the only bank in America connected to a jail, though, as the photograph below shows, that was not always the case. The Rexall drugstore between the two buildings was demolished in 1914 when the bank built its Colonial Revival extension. (Above, courtesy of White Memorial Foundation; below, courtesy of the Van Winkle Family Archives.)

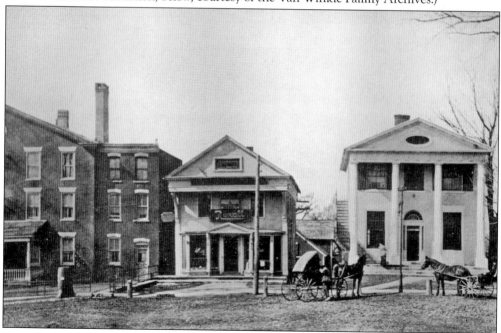

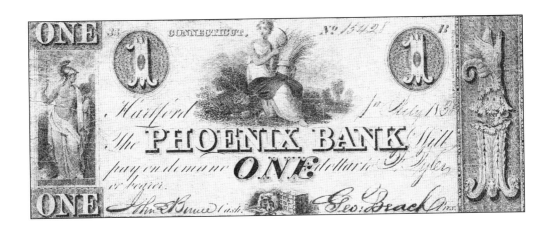

The Phoenix Bank, later the Litchfield Bank, issued its own currency until the United States of America began issuing currency in its own name. The note above, signed in 1838 by the bank's president, George Beach, found its way into the author's collection by way of a collector in the Ukraine. The US government had tried repeatedly and unsuccessfully to introduce paper currency, but without the backing of gold or silver, they were "not worth a Continental." Individual banks were at liberty to print their own currency as long as each was backed by a corresponding gold or silver coin in their vaults. The customer name "T. Tyler" on the Phoenix note, above, suggests that it was used like a traveler's check.

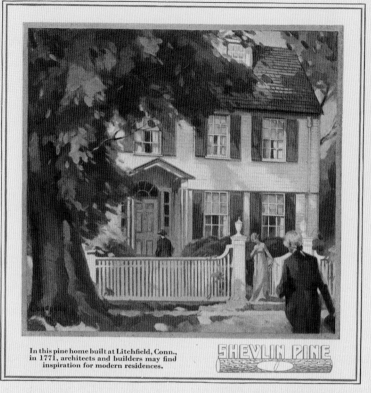

In this pine home built at Litchfield, Conn., in 1771, architects and builders may find inspiration for modern residences.

SHEVLIN PINE

Pine is Always Good Taste

ARCHITECTS and builders who specify pine for modern homes, have their judgment verified by centuries of satisfactory service. Through all the changes in architecture and modes of living, the dignified home of pine has remained perennially "in style."

Modern designers are using pine not only for exteriors of enduring charm but for hospitable pine-paneled living and recreation rooms.

The five varieties of Shevlin Pine make possible a wide range of treatments satisfying to the discriminating builder. Pine of Shevlin quality may be obtained from leading lumber dealers in your town.

The five selected varieties of Shevlin Pine are Shevlin Northern White Pine, Shevlin Pondosa Pine, Shevlin Norway Pine, Shevlin California White Pine, Shevlin California Sugar Pine.

You will have no trouble getting Shevlin Pine as there is a plentiful supply. Through a thrifty policy of selective logging, this enduring material has been safeguarded for generations to come.

For further data write for the booklet, "Specify Shevlin Pine."

Shevlin, Carpenter & Clarke Company
903 First National-Soo Line Building, Minneapolis, Minn.
Chicago Sales Office: 1866 Continental & Commercial Bank Bldg.; San Francisco Sales Office: 1030 Monadnock Bldg.; Toronto, Ontario, Sales Office: 606 Royal Bank Bldg.; Sold in New York by N. H. Morgan, 1205 Graybar Building.

The Lynde Lord house was over 100 years old when Shelvin, Carpenter, and Clarke, of Minneapolis, featured it in an advertisement for their pine lumber. To enhance the cachet of their product to potential customers, their advertisements featured the elegant architectural detail of one of Litchfield's oldest homes. The advertisement reads, "In this pine home built at Litchfield, Conn., in 1771 [sic], architects and builders may find inspiration for modern residences." Shevlin had bought up large tracts of pine forests in Michigan and Minnesota, and the advertisement cites the "plentiful supply" of the company's pine lumber, which had become scarce in the East.

Three

SOUTH STREET

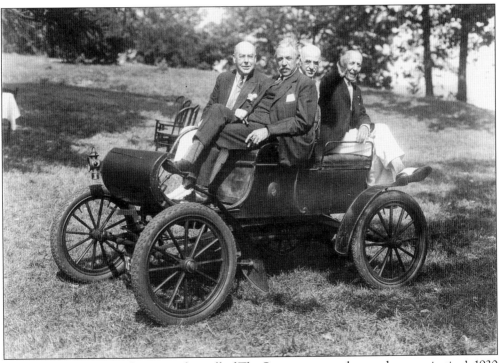

This photograph, which hangs on the wall of The Sanctum, was taken at the organization's 1930 Annual Meeting and features four Sanctum members taking a 1903 curved dash Oldsmobile out for a spin. They would have viewed the then 27-year-old car as a quaint antique. (Courtesy of The Sanctum.)

It was the middle of July 1908, and 28-year-old Alain White had just purchased a state-of-the-art German camera. The cicadas chattered in the elms as he fastened his camera to a wooden-legged tripod. He took a light reading, set the aperture, and waited for a either a horse-drawn carriage or a horseless carriage to come by to provide a foreground subject. When neither materialized, he realized that he already had a subject—the stately elms. He had heard the local rumor that the old trees had grown their upper branches so far outward that they met over the middle of the road, and he documented the rumor with a click of the shutter. (Courtesy of White Memorial Foundation.)

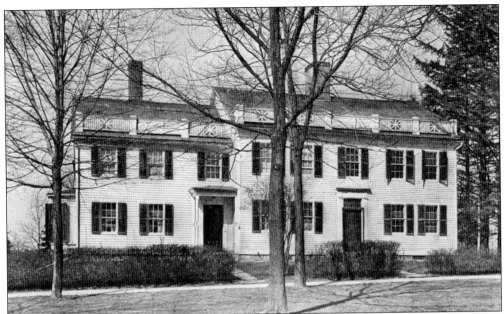

Maj. Moses Seymour built this house in 1807 for his son Ozias, who added the south wing. A subsequent owner was Origen S. Seymour, chief justice of Connecticut. According to local lore, one Mayor Matthews, the Royalist mayor of New York, was held hostage here. It is said that one day he presented his carriage to the Seymour family and "walked abroad for the benefit of the air," never to be seen again. The house remained in the Seymour family until 1950. It is a perfect example of the Federal period of architecture in New England. (Right, photograph by Valerie Vondermuel, from Payne Kenyon Kilbourne; courtesy of Daniel Keefe collection.)

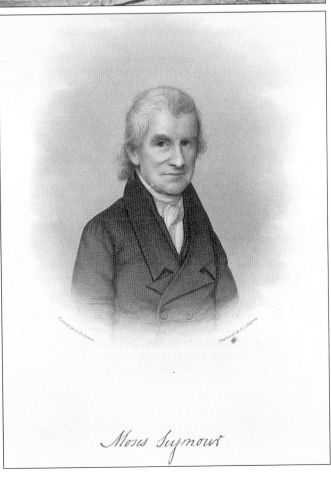

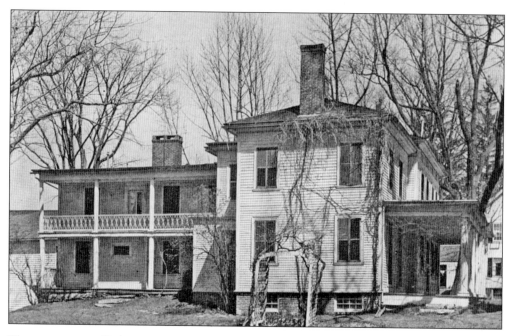

These two views of Judge Tapping Reeve's home, built in 1773, show the remarkable changes some of Litchfield's oldest houses have undergone. Judge Reeve's first wife, Sally, was the sister of Aaron Burr. In this home, Judge Reeve started the lectures that earned his establishment recognition as the first law school in America. The two-story south wing in the earlier photograph above was reduced to one story, but the cast iron railing on the second floor of the west wing attests to the building's identity. Judge Reeve was absentminded and was once seen dragging a bridle, not having noticed that it had slipped off the horse's head. Bystanders chuckled quietly as he hitched the bridle to a post and walked into a building, unaware of his comedic role.

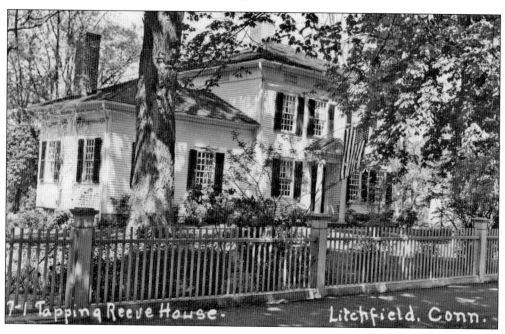

Tapping Reeve came to Litchfield in 1772, and two years later he took his brother-in-law Aaron Burr into his home to prepare him for the bar. The following year he took another student, Stephen R. Bradley, later a senator from Vermont. Judge Reeve served in the Continental Army during the Revolution and reopened his law school in 1778, taking as students Oliver Wolcott Jr. and Uriah Tracey. When, in 1784, his student roster reached 15, he constructed a separate building adjacent to his home to serve as a classroom. (Both, courtesy of Daniel Keefe collection.)

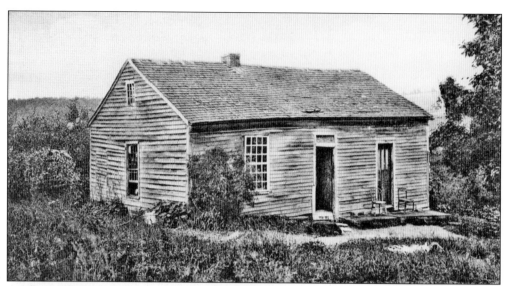

As the number of eager law students increased, Judge Reeve erected, in 1784, a small, frame building to serve as a classroom and library. It was twice removed, first to West Street, where it became an addition to a home, then to East Street. In 1930, it was returned to its original home. This photograph shows the law school as used by Judge Gould, who succeeded Judge Reeve.

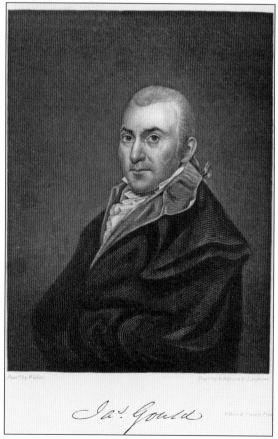

E.D. Mansfield, a student of Judge Gould, wrote in his notes, "The practice of Judge Gould was to read the principle from his own manuscript twice distinctly, pausing between and repeating in the same manner the leading cases. Then we had time to jot down the principle and cases. After the lecture we had access to a law library to consult authorities. The lecture and references took about two hours." (Left, courtesy of Daniel Keefe collection.)

The Samuel Seymour House (not to be confused with the Moses Seymour House, 100 yards north) was built in 1784. Samuel Seymour was a captain in the militia and renowned for razor sharpening. John Caldwell Calhoun, vice president under John Quincy Adams and planter of many of Litchfield's elm trees, roomed here while a student at the law school next door. Later, it was the residence of Oliver Wolcott Jr., and it now serves as the Episcopal rectory.

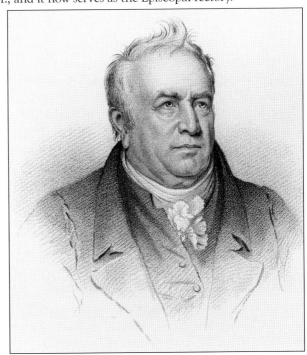

Joseph Hopkinton, a political associate of future Connecticut governor Oliver Wolcott Jr., described him as "a man of a cheerful, even playful disposition. His conversation was interesting and earnest. He enjoyed a good joke, and his laugh was hearty and frequent. He delighted in the discussion of literary subjects." (Photograph from Payne Kenyon Kilbourne; courtesy of Daniel Keefe collection.)

This house was built in 1833 by Lyman Smith. In 1855, the house was bought by John Hubbard, a US congressman from 1863 to 1867. Abraham Lincoln called Hubbard "Old Connecticut." The house exhibits the best of the architecture of the early 19th century, the doorways being especially fine. The piazza on the south is unique, being built around a hawthorn tree providing shade from the sun. The home was shrouded in shade for most of its life by towering elms, frustrating early photographers. These photographs are of the south and main doorways. (Courtesy White Pine Board.)

Payne Kenyon Kilbourne wrote, "In May of 1775 the country was stirred by the capture of Ticonderoga by Ethan Allen which Litchfield is now glad to remember. Ticonderoga, because of its position as a key to the northern waterways, was a triumph for American arms." Ethan Allen was born in this house, originally located in Goshen, and now standing on Old South Road. (Text courtesy of Wyman Publications, Inc.)

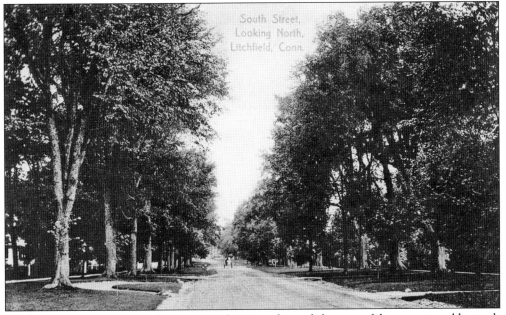

South Street was a very popular scene for early postcards, partly because of the imposing, old-growth elms planted in the Revolutionary era. This photograph was taken facing north approximately where Wolcott Street now enters from the left. The Ephraim Kirby House would be on the right and the Hubbard House on the left. (Courtesy Daniel Keefe collection.)

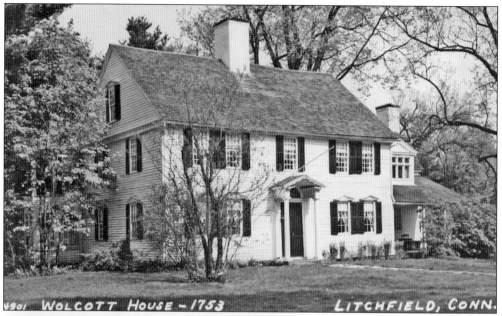

WOLCOTT HOUSE - 1753 LITCHFIELD, CONN.

This house was built in 1753 by Oliver Wolcott Sr., a signer of the Declaration of Independence, a brigadier general in the Continental Army, a member of the Continental Congress, and a governor of Connecticut. Here, he entertained George Washington, the Marquis de Lafayette, and Alexander Hamilton. In its gardens, a leaden statue of King George III was recast into 42,088 bullets for the Continental Army. One of the often neglected documents in the Wolcott archives reads: "Know all men by these Presents, that I, Oliver Wolcott of Litchfield in the State of Connecticut, in expectation that my negro Servant Man, Caesar, will by his industry be able to obtain a comfortable subsistence for Himself and that he will make a proper use of the Freedom which I hereby give him, Do Discharge, liberate, and set free him the said Caesar and to hereby exempt him from any further Obligation of servitude to me." (Photograph from Payne Kenyon Kilbourne; courtesy of Daniel Keefe collection.)

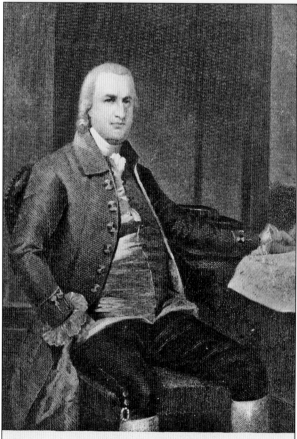

OLIVER WOLCOTT, THE ELDER.

South Street was one of Alain White's favorite photographic haunts. It was on his route when he rode into town from Whitehall. He took this photograph facing south, following an ice storm during the winter of 1908–1909. The sight of the eerie crystalline coating on the old elms has drawn townsfolk out of their warm homes in awed admiration of nature's gift. The photograph below is from an undated postcard and is the same view, just a little further south. It is more foreboding than the photograph at right and shows the flip side of the harsh Litchfield winters, documented by badly damaged elms. (Right, courtesy of White Memorial Foundation.)

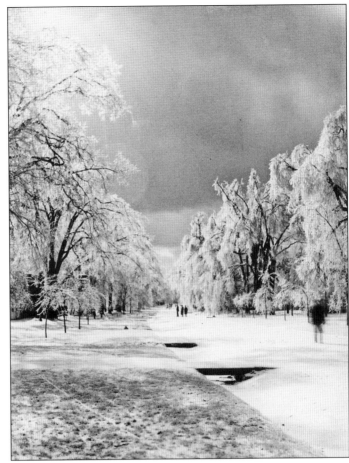

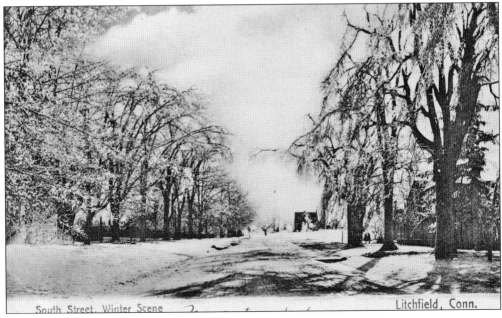

South Street, Winter Scene Litchfield, Conn.

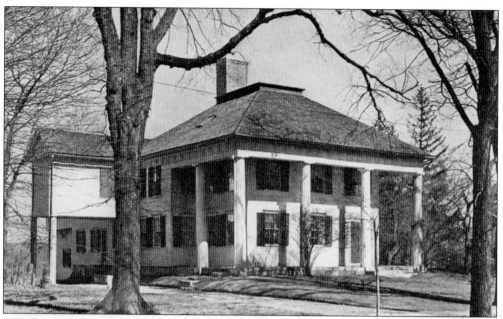

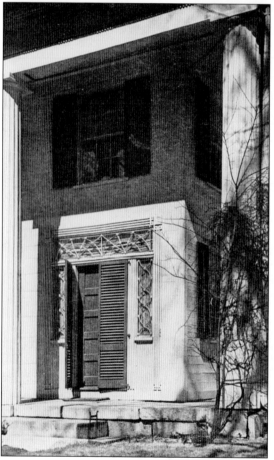

The house popularly known as the William H. Sanford House was built in 1831 for Dr. Alanson Abbee on land purchased from Josiah Barnes in 1830. It is the most faithful representation of Greek Revival architecture in Litchfield. Perhaps most distinctive are the wrapped Doric portico and the steep hip roof. Greek Revival is not well represented in Litchfield for two reasons: its popularity coincided with a period of economic decline and many earlier styles were converted to Colonial Revival in recognition of Litchfield's evolving self-perception. The front doorway is exceptionally executed, with leaded side lights and a transom framing the paneled door. This house eventually succumbed to the Colonial Revival urge with the addition of roof balustrades in the mid-20th century. (Courtesy White Pine Board; text courtesy of the Litchfield Historical Society.)

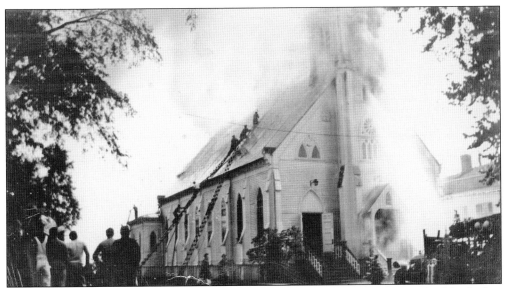

On October 5, 1944, the US Navy began the Battle of Leyte, returning Gen. Douglas MacArthur to the Philippines. That same day, six volunteer firemen on the roof of St. Anthony of Padua Church showed why some heroes were needed at home. Despite their efforts, the church was completely destroyed. (Courtesy of Cleve Fuessenich.)

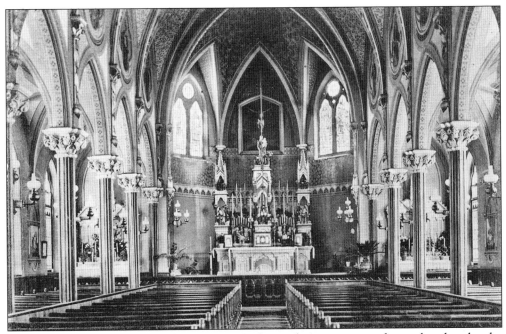

In July 1882, Litchfield's Catholic community obtained recognition and was placed under the patronage of St. Anthony of Padua. It was the second church built on South Street, following the 1812 construction of St. Michael's Church. Following a 1944 fire, a new church was built under the leadership of Fr. Francis Egan and was consecrated on October 24, 1948.

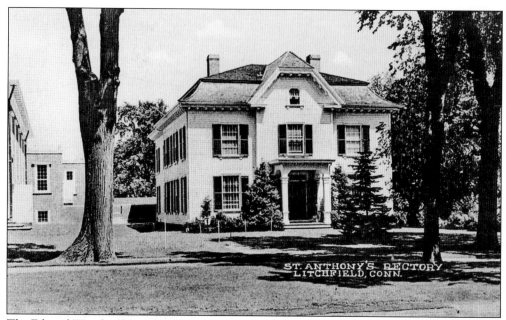

The Edward Woodruff Seymour Home was built in 1863 and became the rectory of St. Anthony of Padua Church in 1936. Judge Seymour served as judge of probate, state representative, state senator, US congressman, and judge of the Connecticut Supreme Court. His wife, Mary Floyd Tallmadge, was the great-granddaughter of Col. Benjamin Tallmadge. (Courtesy of the Van Winkle Family Archives.)

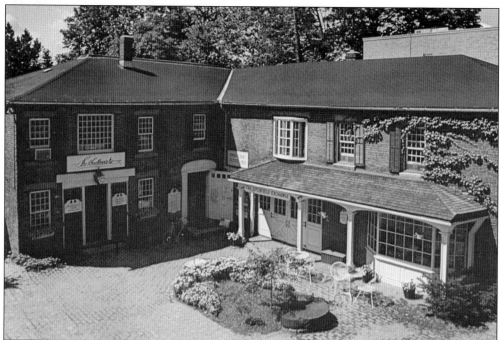

The cluster of buildings comprising Cobble Court were designed by Thomas Buckley and included the blacksmith shop, stables, paddock, and tack shop associated with Mansion House, the picturesque hotel that was lost in the 1886 fire. The cobblestoned area was the original horse paddock.

Clock maker and bell caster Benjamin Hanks built this double house in 1780, and it served as both his home and workshop. Hanks had been a drummer in the American Revolution and settled in Litchfield in 1790. At one time this building served as the Park Hotel. Prominent in the foreground of this photograph is the "Connecticut Sycamore," planted by Oliver Wolcott Jr. (Courtesy of Hastings House/Daytrips Publishers.)

The Phineas Minor House was built in 1820 and served as the attorney's law office. It was enlarged by Silas N. Bronson for use as a retail shop, and it was the original home of the Litchfield County Historical and Antiquarian Society. It now serves as the clubhouse for The Sanctum. The Sanctum was founded in 1906 for New York families to congregate after their long carriage rides from New York City. (Courtesy of The Sanctum.)

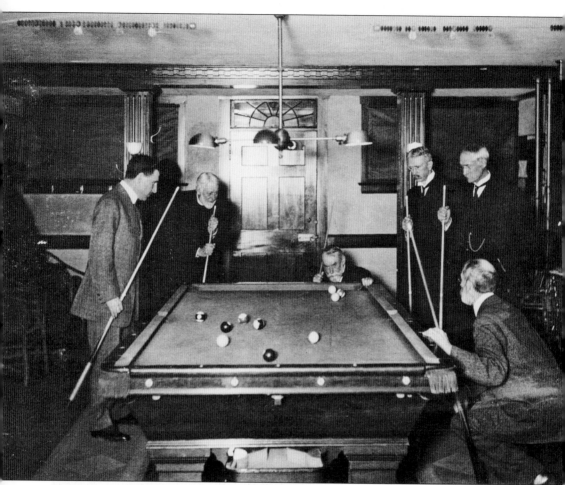

In this photograph, original Sanctum members are testing Sir Isaac Newton's first law of motion. This room features a purpose-crafted perimeter step, enabling spectators to get a better view of the billiards table from a respectable distance. The exposed pipes to the right of the photograph show that central heating was added later since such pipes would typically be located inside walls. The gentleman on the left is Seymour Cunningham, one of the original Sanctum founders and the founder of the first golf club in Litchfield, the Bantam River Golf Club, which eventually became the Litchfield Country Club. (Courtesy of The Sanctum.)

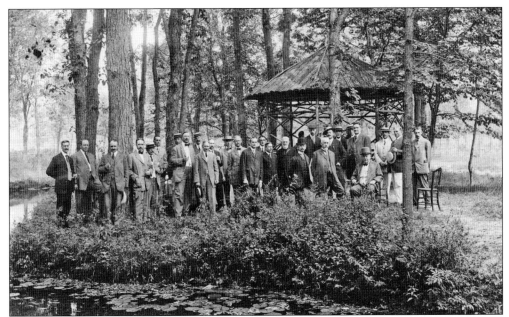

The 1908 photograph above and the 1910 photograph below show Sanctum members at their annual summer picnics, hosted by Alain White at White's Woods. The Sanctum was founded by six New Yorkers with homes in Litchfield: Col. George B. Sanford, Dr. John L. Buell, Seymour Cunningham, W.G. Wallbridge, Louis A. Ripley, and Origen S. Seymour. They met at the Albemarle Hotel on February 1, 1906 "for the purpose of constituting a club for mutual improvement, literary, and social purposes." Minors and dogs were not allowed, and the maximum single wager was set at 10¢. During World War I, The Sanctum turned the clubhouse over to nurses who prepared bandages for the wounded. Club life resumed after the war, and The Sanctum again became known as a quiet refuge with an excellent bar. (Courtesy of The Sanctum.)

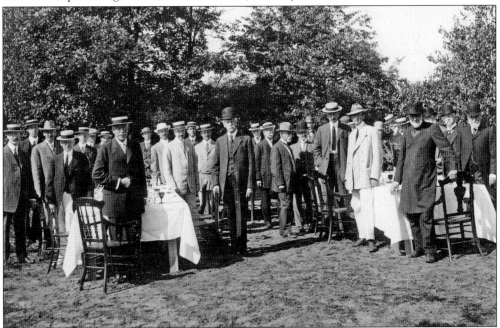

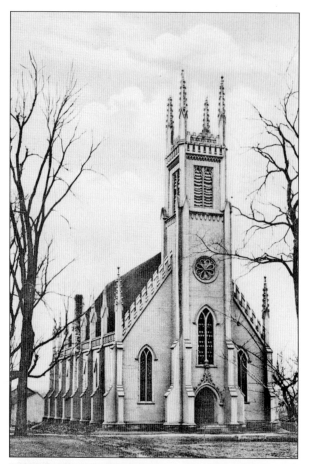

The first Episcopal church was erected a mile west of the village in 1749. The second church was built on this site in 1809–1812 on a lot donated by Samuel Marsh in 1808. The third church, at left, was completed in 1851 in this location but was moved to make the lot available to construct its successor. The current St. Michael's Church, built in 1921, is made of Roxbury granite in the English Gothic style. The stone was given by Henry R. Towne in memory of his wife, Cora. The interior wood is entirely chestnut and oak. The floor tiling is copied from the 15th-century Castle Acre Priory in Norfolk, England.

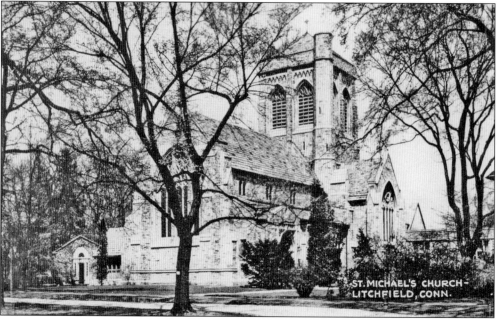

ST. MICHAEL'S CHURCH–
LITCHFIELD, CONN.

Four

EAST AND WEST STREETS

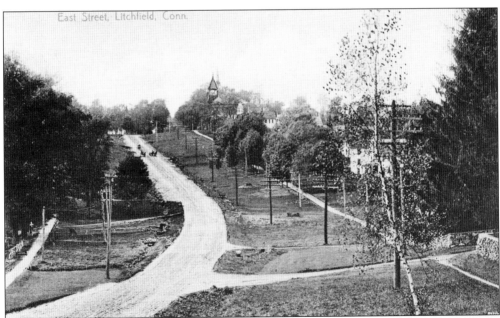

East Street was the last hill that travelers and their horses would have to climb to reach Litchfield from the population centers to the east and south. Anyone arriving from the Connecticut River Valley (Hartford or Windsor), the Connecticut shoreline (New Haven or Bridgeport), or New York would arrive in this direction. The old Litchfield High School is visible at the top of the hill on the right. (Courtesy of the Van Winkle Family Archives.)

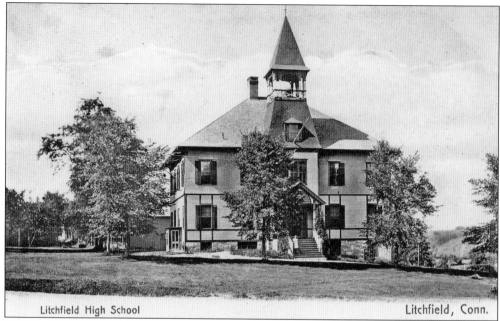

Litchfield High School Litchfield, Conn.

Litchfield High School, built in 1888, stood at the top of East Street. It admitted any local student who had completed the eighth grade in any of Litchfield's elementary schools. The requirements for nonresident students may seem excessively harsh by today's modern politically correct standards. Applicants were required to pass an admissions test comprising English, arithmetic, geography, and US history, and they had to understand English grammar. For an applicant who met that requirement, the nonresident tuition was $20 per year. (Text courtesy of Litchfield Historical Society.)

The post office building was originally constructed by Dr. Josiah Beckwith Jr. in 1896. It was designed as a commercial building with two storefronts on the first floor, professional offices on the second, and a residential apartment on the third. It is one of the best preserved Colonial Revival commercial buildings in the state. This photograph was taken prior to the 1982 addition of the north ell.

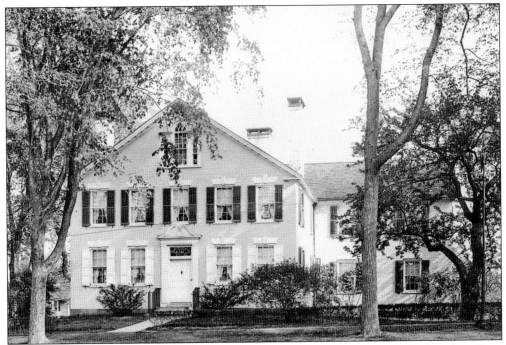

Built in 1814, this tan brick Federal-style home has its entrance on its gabled end, under a beautiful Palladian window. It is the oldest brick residence in the historic district. In the 1950s, owner Marian Doughty Camp restored the house magnificently. It has seven fireplaces and wide oak floorboards.

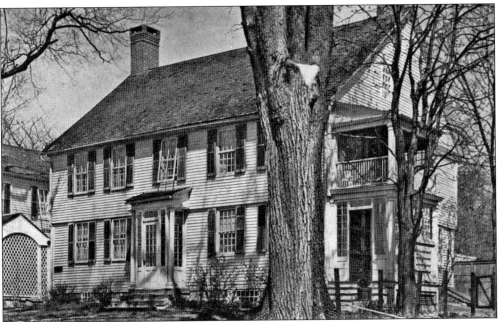

John Collins constructed this building as a tavern in 1782. Known as the Phelps House, or Charles Bennett House, it is the oldest building on East Street. There was a bar in the southwestern part of the front room and a ballroom at the rear. It remained in the Phelps family for 100 years.

This intersection is the top of West Hill; Meadow Street is to the left. Nearly all vintage landscapes of Litchfield feature elms, and this is no exception. An elm looms in the left foreground, and elms line West Street in the distance. The fire hydrant visible off to the right dates the image to the early years of running water.

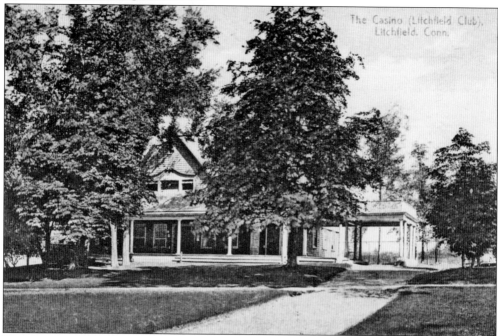

The Casino was designed by S. Edson Gage and opened in 1894. It was located where the present town hall now stands on West Street. From 1894, it was known as the Litchfield Club House. In 1919, the Litchfield Garden Club acquired it and it became the Litchfield Playhouse, also the Community Playhouse. It was demolished in 1949.

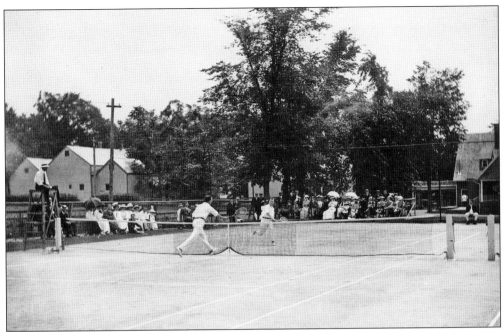

The Litchfield Club House, also known as the Casino or Litchfield Playhouse, hosted the 1909 Connecticut State Tennis Championships, captured here by Alain White. Despite the hot, mid-July heat, the players wore full tennis whites. The racquets were wooden and strung with catgut. (Courtesy of White Memorial Foundation.)

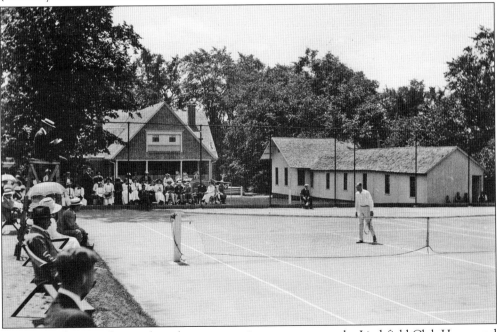

This 1910 photograph was also taken at a tennis tournament at the Litchfield Club House and shows a rare view of the northern side of the clubhouse. In addition to tennis, the Litchfield Club House hosted dramatic performances. This location is now the parking lot behind town hall. (Courtesy of White Memorial Foundation.)

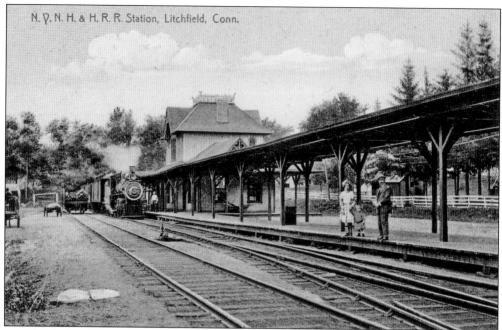

Litchfield was the eastern terminus of the Shepaug Railroad, completed in 1872, when the Litchfield station house was built. The other end of the Shepaug line was Hawleyville, where it met the Housatonic Railroad. The Shepaug was never a financial success. In 1892, it was leased to the New York, New Haven, and Hartford Railroad, which operated passenger service until 1931 and freight service until 1948. (Courtesy of Leroy F. Roberts.)

The turntable to reverse the direction of the train was just north of the station house. The only part of the original building still remaining is the frame at the north end. Popular Litchfield physician C.H. Huvelle swore he had been a passenger on that last train from New York in 1931. (Courtesy of Walter D. France.)

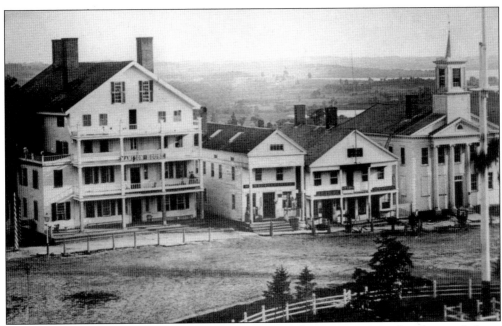

Tourists often find that the dull brick facade along the village green is not what they might have expected in a town that celebrates its founding 56 years before the Revolutionary War. What they do not consider, however, is that fire provided the only heat and the only light for the town's first 200 years. During that time, any unattended flame could engulf a building, and if that structure were close to others, as in a town center, one person's momentary inattention could cause that town to disappear in hours. These two images depict the town as it appeared prior to the 1886 fire and how it looked shortly after being rebuilt with fireproof materials. Lost in the fire was the original courthouse and a hotel known as Mansion House. With the landscape denuded of trees, both Little Pond and Bantam Lake are visible in the earlier photograph. (Above, courtesy Litchfield Historical Society.; below, courtesy Daniel Keefe collection.)

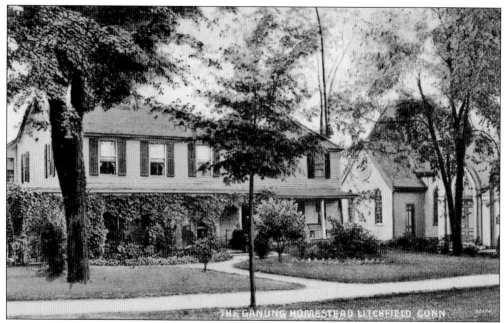

Built in 1789 by Joseph Adams, the Ganung Homestead once stood next to the United Methodist Church, visible on the right. The Episcopal pastor, Rev. Truman Marsh, and his wife, Clarissa, resided in this house beginning in 1823, and it remained in the Marsh family until 1880. The C.M. Ganung family later operated a grocery store here until it was divided into two separate houses, both now located on Meadow Street. (Text courtesy of the Litchfield Historical Society.)

Methodist Episcopal Church Litchfield, Conn.

Most of Litchfield's High Victorian Gothic architecture was either demolished or infected with Colonial Revival, but not the United Methodist Church. Built by a local contractor, Leonard Stone, the church has been preserved with historically appropriate accuracy, right down to the multihued exterior paint scheme. (Courtesy of the Van Winkle Family Archives.)

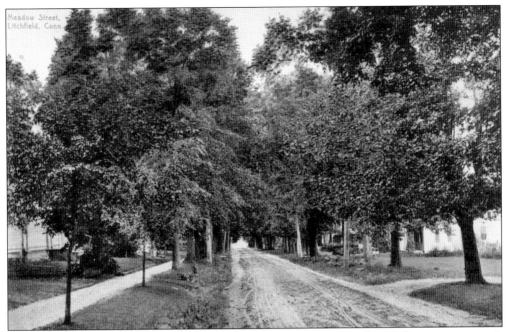

Meadow Street, seen in this 1904 image, was a miniaturized version of South Street, just a stone's throw to the west. Meadow Street has always had a more off-the-beaten path feel than its parallel cousin. And, as with South Street, the trees flanking the road met overhead, providing a natural, shady canopy. (Courtesy of the Van Winkle Family Archives.)

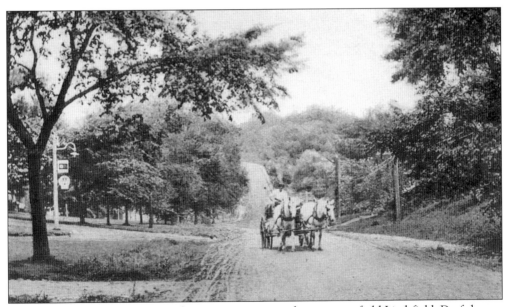

This photograph of West Street, facing west, captures the essence of old Litchfield. Draft horses labor to haul freight up the hill from Bantam and the railroad station at the bottom of the hill for delivery in town. The sign for the Berkshire Hotel is on the left. (Courtesy of the Van Winkle Family Archives.)

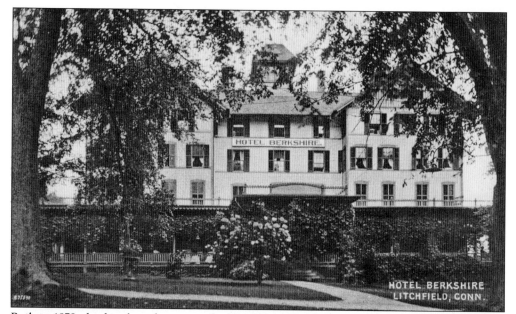

Built in 1878, this hotel was known as the Hawkhurst Hotel until owner Harry Clinton changed its name to the Hotel Berkshire in 1908. It stood where the current Center School is located. They advertised the following: "Only three hours from New York by the Litchfield Special Express Train. Music by the Famous Hotel Berkshire Orchestra. Rates: $12 to $18 per week, including board."

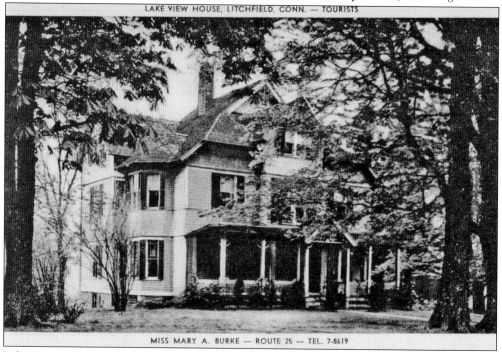

Lake View House was an inn owned by Mary A. Burke, and it once stood at the present intersection of West Street and Woodruff Lane. Today, the name seems perplexing, but in the waning years of the 19th century, there were no trees to block the view of Bantam Lake. Lake View House was demolished in 1919.

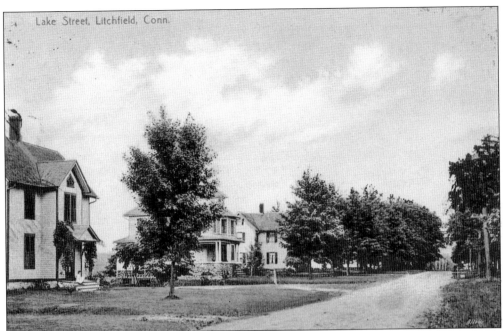

Labeled only Lake Street, this view faces south on the current South Lake Street. It was clearly a newer neighborhood, as testified by the younger trees along the road. This neighborhood, originally rather sleepy, became a hub of activity when the nearby Shepaug Railroad was introduced. (Courtesy of the Van Winkle Family Archives.)

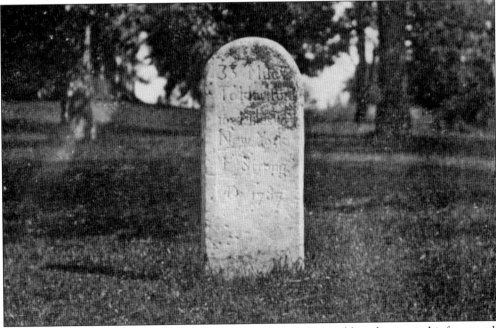

Brilliant, deformed, and eccentric, Jedediah Strong placed this marble milestone in his front yard, now that of the Litchfield Bancorp. It is still legible today: "33 Miles to Hartford 102 Miles to New York J. Strong AD 1787." Behind it is Elm Ridge, named for the stand of elms planted by Lyman Smith before the Civil War. (Photograph by Alice T. Bulkeley; courtesy of the *Hartford Press*.)

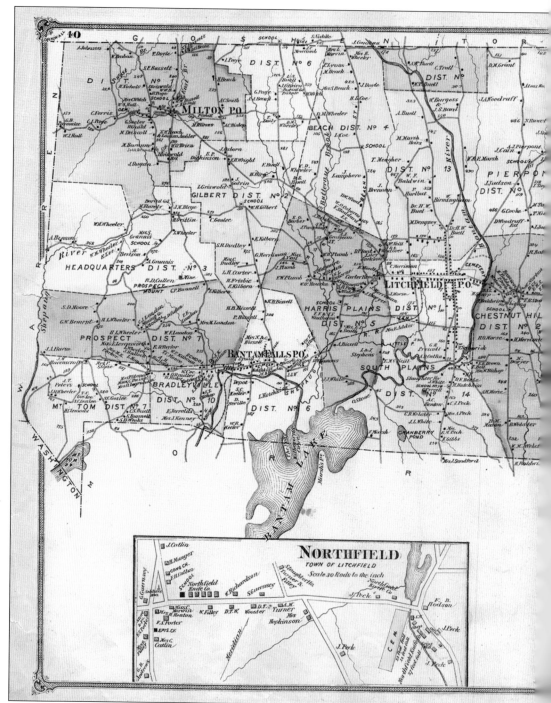

This map was published in 1874 by F. W. Beers of 36 Vesey Street, New York. Litchfield is bounded by the Naugatuck River to the east, Bantam Lake to the south, the Shepaug River to the west, and Goshen and Torrington to the north. Bantam Falls, Milton, and Northfield were considered part of Litchfield. Mount Tom Pond is at the southwest corner. The map shows the 15 districts comprising the town, each with a name, such as "East Chestnut Hill District, Number

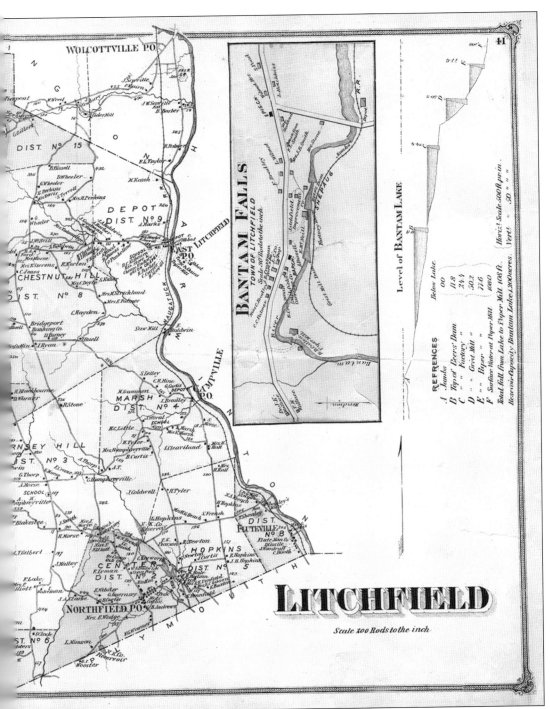

8." Principal land owners names appear on the map. Many of the homes depicted in this book are represented on the map. For instance, "Mrs. C. Dudley," is the Charles Dudley House on Maple Street, Bantam Falls. The map also depicts schools and mills. The millpond above the Biglow Mill is visible at the bottom of Camp Dutton Road.

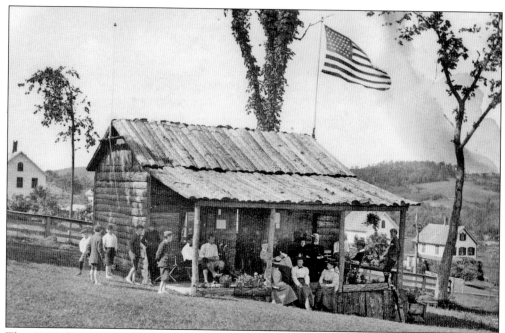

This 1903 photograph of the Bantam River Golf Club clubhouse, located on East Street, shows barefoot children in plus fours, an imposing elm in the rear, a hanging plant, and elegantly attired ladies. Then there is the matter of the American flag, which, with 45 stars, was after Utah had been admitted to the Union but before Oklahoma. (Courtesy of Litchfield Country Club.)

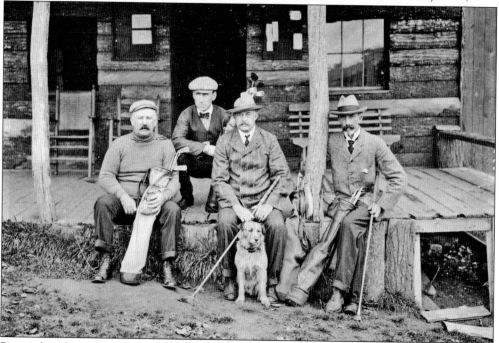

Pictured in this 1903 image of the Bantam River Golf Club are, from left to right, Capt. Willis, Seymour Cunningham, L.F. Bringham, and W.A. Sanford. The dog's name is Joe. (Courtesy of Litchfield Country Club.)

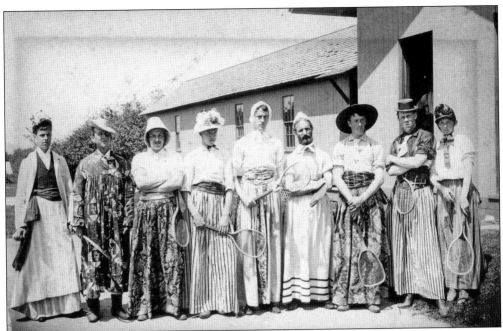

This 1890 photograph shows the Litchfield Lawn Club's ever-popular cross-dressing tennis tournament. The Litchfield Lawn Club was one of the two predecessor organizations, along with the Bantam River Golf Club, of the Litchfield Country Club. (Courtesy of Litchfield Country Club.)

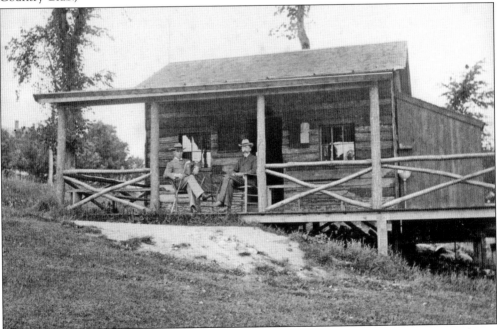

This photograph is undated, but it is the same Bantam River Golf Club clubhouse as shown earlier, with some capital improvements. The roof has been shingled, railings added, and Seymour Cunningham has discovered where Edgar Van Winkle bought his hat. The small sink on the right shows that running water has been installed. (Courtesy of Litchfield Country Club.)

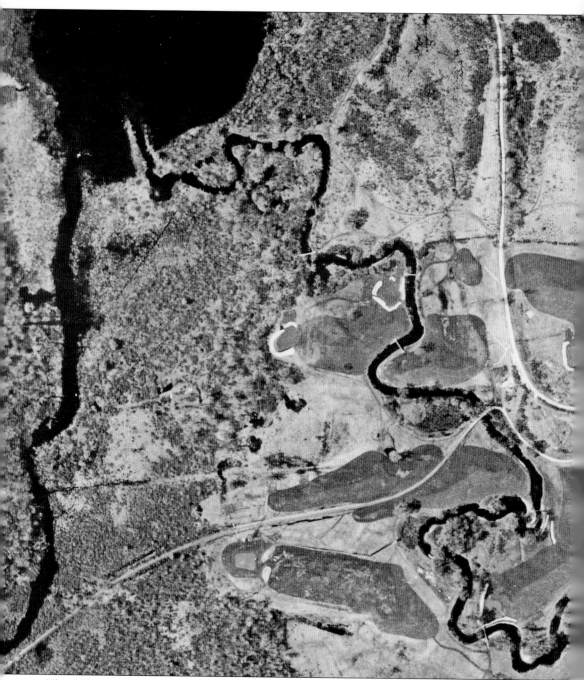

This 1934 aerial photograph shows the Bantam River as it winds through the flood plain where the Litchfield Country Club is located. The road on the far right is Route 63, the Litchfield-Morris Road. The dark patch at the top left is Little Pond. The river runs east to west in its curly segment, and on the far left it flows south toward Bantam Lake. The road that curves to the north formerly connected to South Lake Street and was open seasonally to through traffic until 1970. The road that wound down to the southwest went along the river to White's Woods Road. The Litchfield Country Club had been in existence in this location only 18 years when

this photograph was taken, and Ludlow Bull was the president. The clubhouse was unchanged since Alain White acquired it from Howard Catlin. The tennis courts are clearly visible, as is the first platform tennis court, which has since been swallowed by the hungry swamp below it. The sand hazards have all been relocated. And though the basic orientation of the fairways will be familiar to current club members, the course is now played quite differently than it was then. (Photograph by Fairchild Aviation; courtesy Connecticut State Library.)

Until this appeal to Litchfield townsfolk surfaced, the challenge of financing a golf course in Litchfield in 1909 could only be imagined. The annual cost of running the Bantam River Golf Club in 1909 was $1,100. But with receipts coming in at only $600, the deficit was a ruinous $500 annually. The solution was a membership drive. With an initiation fee of $25 and annual dues of $15, the Board of Governors could close the gap with 12.5 new members. But Litchfield's Golden Age had ended in 1834, with industry, and therefore wealth, concentrated in the valley towns with their water-powered mills. Civic-minded Litchfield residents had donated the firehouse and the library, but the golf club had to go begging. (Courtesy of Litchfield Country Club.)

Five

OUTSKIRTS

Litchfield comprises Litchfield, East Litchfield, Northfield, Bantam, Warren, Morris, Goshen, and Milton. Fortunately many vintage images survive to show some of these towns as they appeared long ago. This photograph shows one of Hans "Boisie" and Sonia "Sunny" Seherr-Thoss's dairy cattle in Milton. (Courtesy of Perley Grimes.)

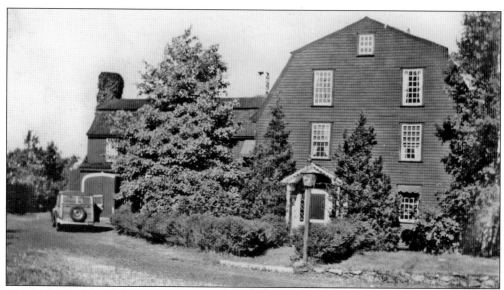

This building originally stood on what is now called the Old East Litchfield Road and operated as an inn under the name Captain William Bull Tavern from 1745 to 1923. In 1921, it was purchased by Frederick and Jean Fuessenich and, in 1923, relocated to its present site where it became the Toll Gate Hill Inn, in recognition of its proximity to the former highway toll collector just down the hill. The photograph below shows the reconstruction of the building in 1923 from carefully numbered pieces disassembled from the original Bull Tavern. Frederick Fuessenich stands with the workmen. (Both, courtesy of Cleve Fuessenich.)

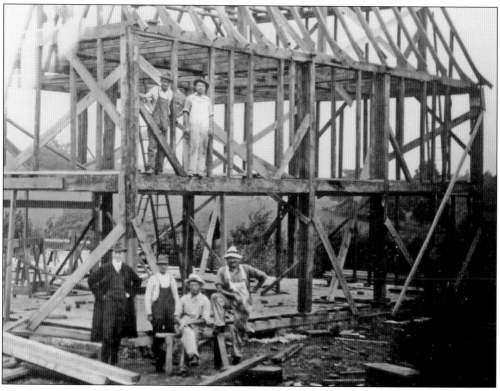

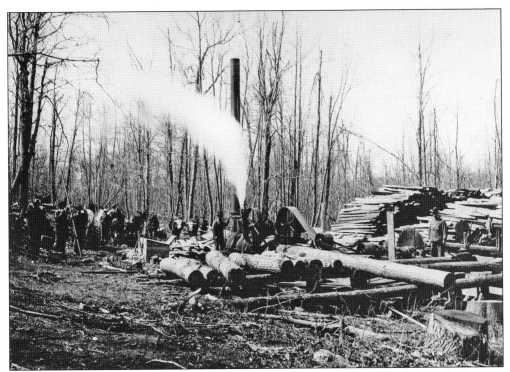

These photographs show a steam-powered, open-air sawmill, which operated along the Bantam River at the bottom of Camp Dutton Road. The mill was operated by the Biglow family, and its peak operating years were from 1875 to 1900. The above image shows a steam-powered saw, and the photograph below shows log inventory and a drying house. A gristmill, built about 1740, originally stood at this site and was operated by the descendants of Litchfield founding father John Marsh. A replacement mill was built to card wool and press fruit, depending on the season. The steam-powered sawing operation depicted here was independent of river power, but it employed the buildings and other infrastructure, which its water-milling predecessors had left behind. Massive iron turbines, belt sprockets, and a steel flume still lie along this stretch of the river. (Both, courtesy of John Fahey.)

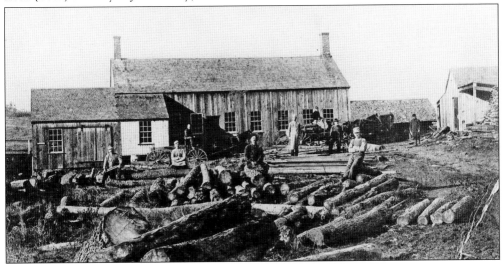

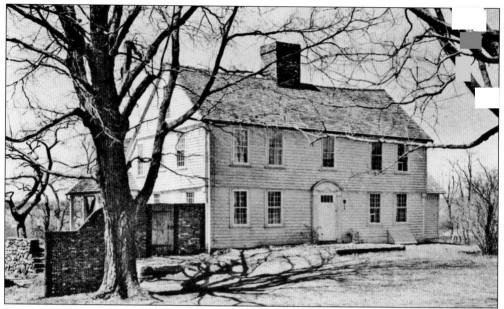

Parts of the Edward Phelps House, also called the Richards House, were originally built in 1723 on Collins Road, off Fern Avenue. Its distinctive architectural features include the double overhangs between floors, the entrance detail (a later addition), and its symmetry, highlighted by an immense central chimney. (Courtesy Hastings House/Daytrips Publishers.)

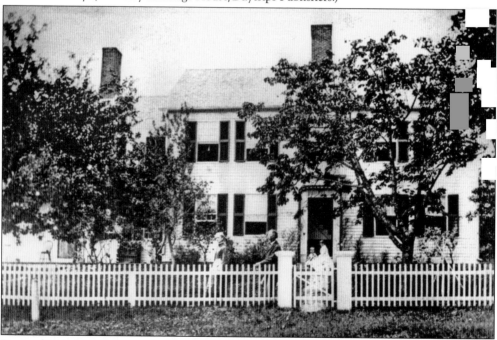

Pictured is the farmhouse at the Top O' World Farm on Chestnut Hill Road before a substantial addition in the 20th century to accommodate a large pipe organ. It was a working horse farm with bounteous pastureland and stunning views to the west, south, and east. It was, in the words of a former owner, "a showplace and sanctuary for its inhabitants, both human and animal." (Courtesy of Top O' World Farm owners.)

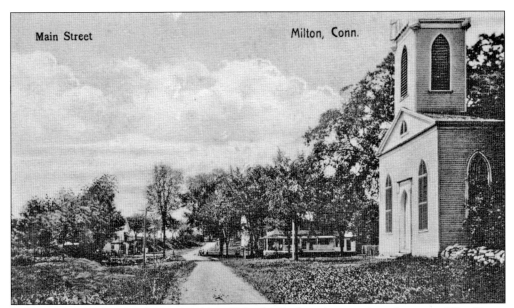

Milton was settled in 1740 by Litchfield and New Milford residents and was known as West Farms until 1795. Now a very quiet town, it once had five sawmills, two gristmills, two iron works, and six schoolhouses. Milton has some of the oldest houses in the Litchfield area. The David Welch House, now known as the Bissell House, dates from 1756. The Samuel Burgis House was built prior to 1774. The house known as the Welsh House dates from 1774. The Oliver Dickenson House was built in 1775. Trinity Episcopal Church was built in 1826 but, so the story goes, could not be consecrated until its debts were paid off in 1837. The church was designed by Oliver Dickenson and modeled after the second Trinity Church on Wall Street in New York City. The belfry and steeple were replaced after being struck by lightning in 1897 (Below, courtesy of the Van Winkle Family Archives.)

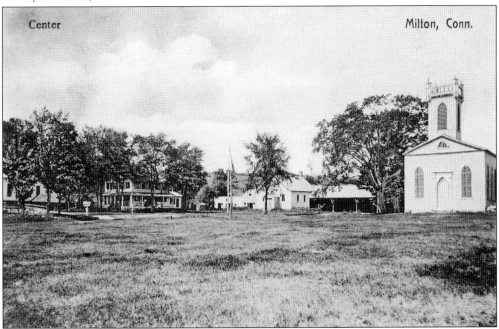

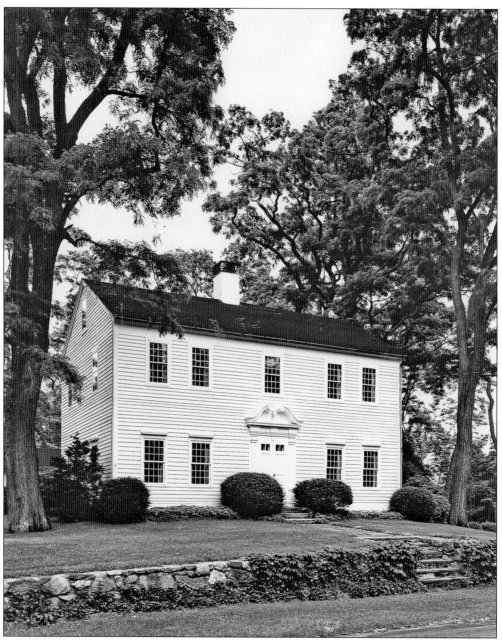

Samuel Burgis purchased this property in 1774 with the home already standing; its construction date was unrecorded. Purchased by David Page in 1776 for the sum of 135 pounds sterling, it remained in the Page family until 1923. This section of Milton was called "Blue Swamp" after the proliferation of Gentian Violet, used medicinally as an antifungal agent. (Courtesy of Joyce Cropsey.)

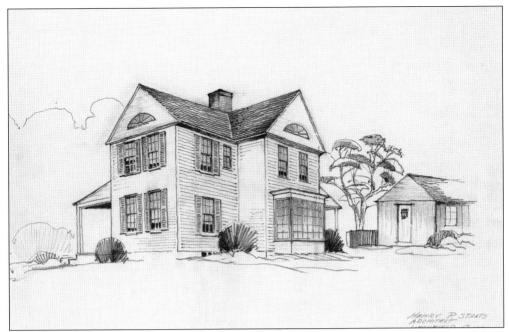

In 1923, Old Lady Campbell, as Elvira Campbell was known, commissioned a young Litchfield architect, Henry P. Staats, to show her what a solarium would look like on the southern wall of her 1888 T-shaped Norfolk Road farmhouse. Staats went on to develop a reputation as a restorer of historic homes in Charleston, South Carolina. Old Lady Campbell opted against the solarium.

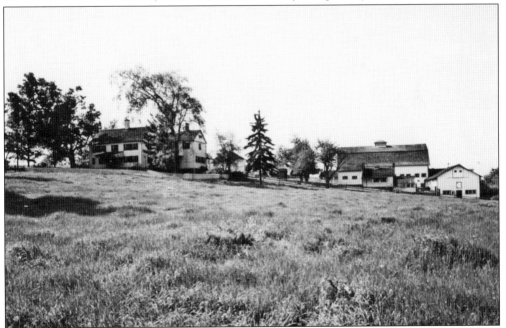

The D.W. Wheeler House was built in 1780 as a classic center-chimney Colonial, and its conversion to the Greek Revival style was very well executed. It is located at the intersection of Hutchinson Parkway and Mike Road and was the farmhouse for the Seherr-Thoss dairy operation. The house is rich in architectural detail, and its setting is stunning. (Courtesy of Perley Grimes.)

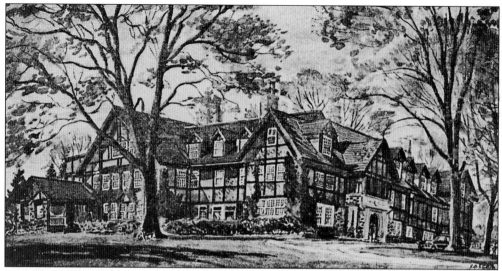

Kilravock was a Tudor-styled mansion built on Brush Hill Road in 1905 by Louis R. Ripley on 1,200 acres of land originally purchased in 1884 by Julie Dillon Ripley. It was designed by the New York City–based firm Pickering and Walker. It burned to the ground in the summer of 1977. The Ripley family always referred to it as the Big House.

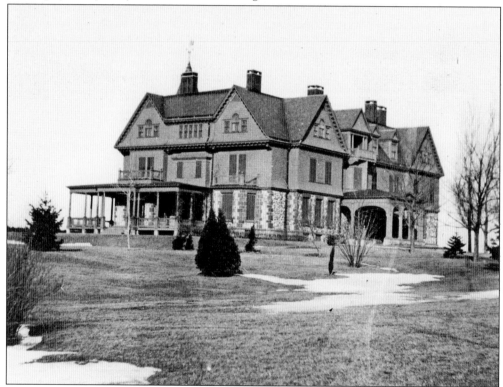

Hillhome, built in 1892, was designed by McKim, Mead, and White for Edgar Beach Van Winkle and was one of the grandest homes and most beautiful properties in all of Litchfield. It was located on North Lake Street. The house was heated by six coal furnaces, and it was one employee's sole responsibility to keep them stoked. (Courtesy of the Van Winkle Family Archives.)

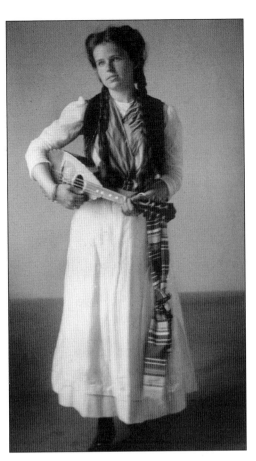

These photographs depict Dorothy Bull, right, and Eleanor Lindley, below, in costumes for a dramatic performance of A *Midsummer Night's Dream* at Whitehall, the home of Alain and May White. May enjoyed staging dramatic works, and Alain took photographs for their photo album. One play featured prominently in their album was *Alice in Wonderland*, which was staged outdoors. (Both, courtesy of White Memorial Foundation.)

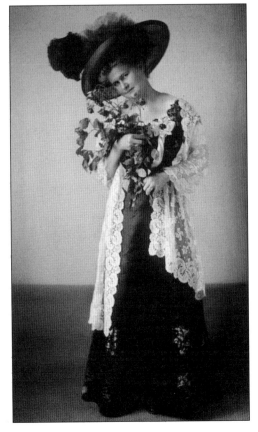

The former F. Norton Goddard estate now houses the Education Connection. Goddard dedicated his life to fighting vice and corruption. His most notable accomplishments were rooting out New York's policy racket and in shaming Western Union out of its complicity with "wire houses" that allowed illegal off-track betting, as immortalized in the movie *The Sting*.

Stonecroft, a 1925 Tudor mansion, was built as a seasonal retreat by New Yorkers Richard and Lura Liggett. The architect was Richard Henry Dana, who took his inspiration from the cottages of the Cotswalds. The Liggetts lived here until Lura Ligget's death in 1947, when it was purchased by the Missionaries of the Company of Mary, known as the Monfort Brothers.

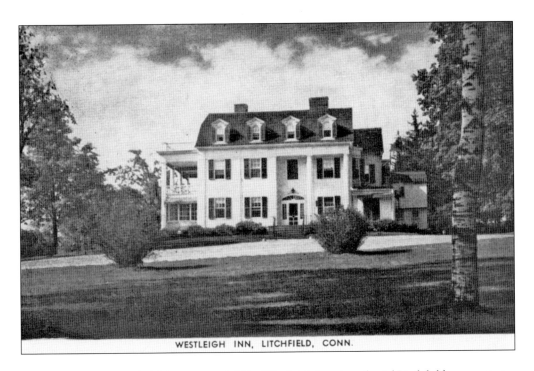

WESTLEIGH INN, LITCHFIELD, CONN.

A 1972 article in *New York Magazine* read, "The Westleigh Inn, in colonial Litchfield, concentrates on fine food, but it does have guest rooms: one flight up at $18 the night for two people, two flights up at $16 the night. The inn's reputation is really based on the high quality of its food, but it's also the last word in peace and quiet if you decide to stay for a weekend." Located on the property the Westleigh Condominiums now occupy, the Westleigh Inn was given its Georgian Colonial appearance in 1909 by Col. Albert Lamb.

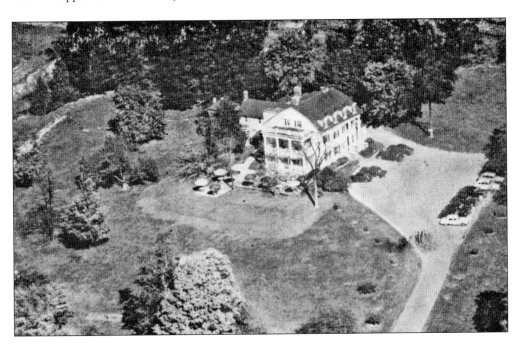

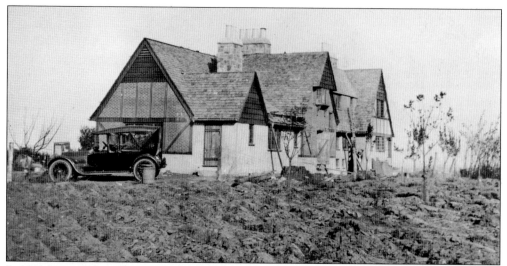

In 1917, Henry Sabin Chase, president of Chase Brass and Copper in Waterbury, gave his daughter Edith Morton Chase a small cottage on 16 acres of land in East Litchfield. In 1923, Edith engaged architect Richard Henry Dana to transform the cottage into a grand Tudor Revival mansion. The result was Topsmead, seen here under construction. The interior has been preserved as Edith Chase left it. Her books are seen on either side of the fireplace, and her study is just behind it. In fact, the entire 600 acre estate will be preserved in perpetuity since it is now under the administration of the Connecticut Department of Environmental Protection and designated as Topsmead State Forest. (Courtesy of Connecticut DEP, Topsmead State Forest.)

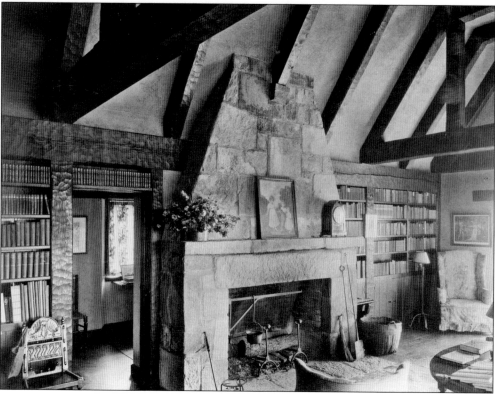

Six

BANTAM, BANTAM LAKE, AND BANTAM RIVER

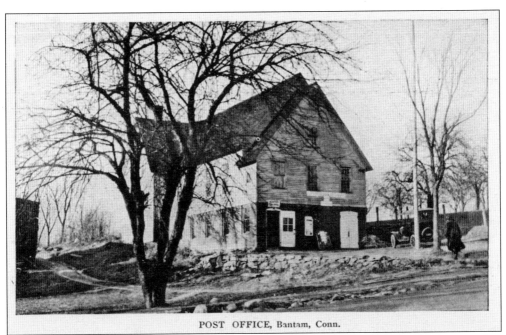

POST OFFICE, Bantam, Conn.

Bantam is the only one of Litchfield's townships that possessed a concentration of industry, owing to the fact that the Bantam River drops quickly through the town, providing power for the mills. In fact, the old maps, including one in this book, show the town as "Bantam Falls." Here is the Bantam Post Office as it appeared about 1906. (Courtesy of the Van Winkle Family Archives.)

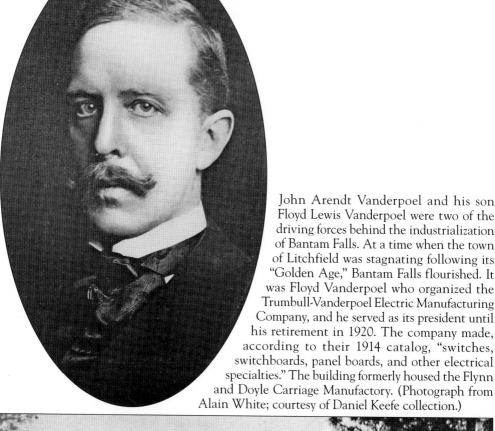

John Arendt Vanderpoel and his son Floyd Lewis Vanderpoel were two of the driving forces behind the industrialization of Bantam Falls. At a time when the town of Litchfield was stagnating following its "Golden Age," Bantam Falls flourished. It was Floyd Vanderpoel who organized the Trumbull-Vanderpoel Electric Manufacturing Company, and he served as its president until his retirement in 1920. The company made, according to their 1914 catalog, "switches, switchboards, panel boards, and other electrical specialties." The building formerly housed the Flynn and Doyle Carriage Manufactory. (Photograph from Alain White; courtesy of Daniel Keefe collection.)

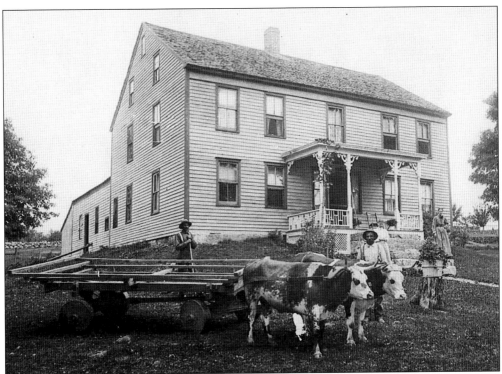

Born in Britain, Charles Dudley tried his hand at farming in Milford, Connecticut, but found the cost of land too high. In 1815, he relocated to Bantam and built this classically designed post and beam New England farmhouse on what is now Dudley Road. It has oak and walnut floors, four fireplaces, and a "bee hive" oven. (Courtesy of Peter Onderdonk.)

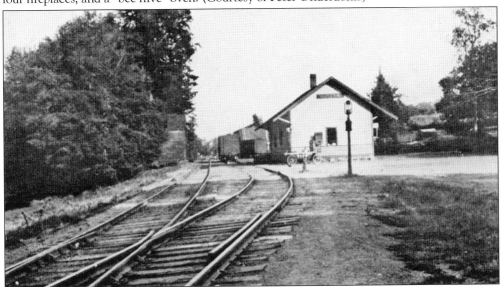

The Bantam Railway station once stood beside the Bantam River near the current Bantam Fuel depot. This was the same line, the Shepaug Valley Railroad, that served Litchfield and that hauled the ice from Bantam Lake, carriages from Doyle and Flynn, and switches from Trumbull Vanderpoel to the New York market. Passenger trains ran twice daily.

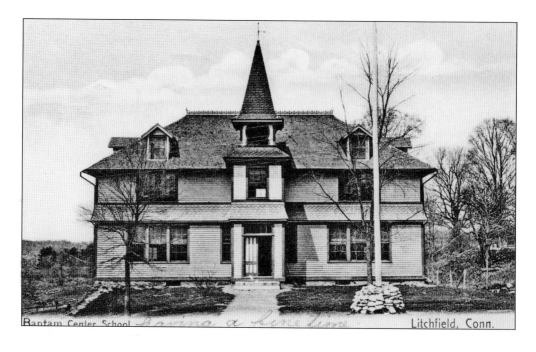

Bantam Center School *Souvenir a Line Line* Litchfield, Conn.

The Bantam Center School was built in 1893 and was at the heart of Bantam life for 63 years until its closing in 1956, when Bantam students began attending Litchfield Center School. The building featured a hipped roof with a large overhang and a flared band of wood shingles between the first and second floors. It is now known as the Ebner Building and is one of the grandest buildings in Bantam's commercial district. The design of this school is nearly identical to that of the old Litchfield High School, which was built five years earlier.

SCHOOL, Bantam, Conn. Hand Colored

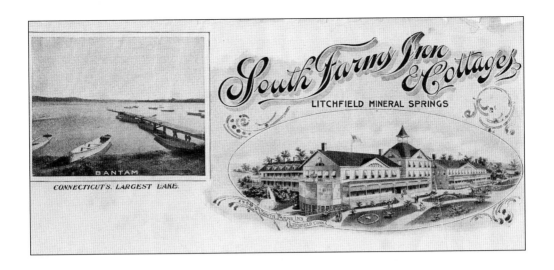

BANTAM

CONNECTICUT'S LARGEST LAKE.

South Farms Inn & Cottages

LITCHFIELD MINERAL SPRINGS

The marketing brochure above considerably exaggerated the size of South Farms Inn; the modest dimensions in the dining room photograph below provide a more accurate scale. This inn was owned by Charlotte M. Schermerhorn and was located atop what is now Schermerhorn Hill, across the Litchfield line into Morris. In the early 20th century, there were no trees there and the inn had a partial view of Bantam Lake. In 1903, quite a scandal broke out when Charlotte Schermerhorn transferred title to the inn to her son, who immediately sold it. Charlotte then filed suit to reverse the conveyance to her son on the grounds of her own mental incapacity. The ruling by Judge Loomis determined that she was in fact of quite sound mind, and the conveyances stood. Schermerhorn Hill is now part of White's Woods. (Both, courtesy of White Memorial Foundation.)

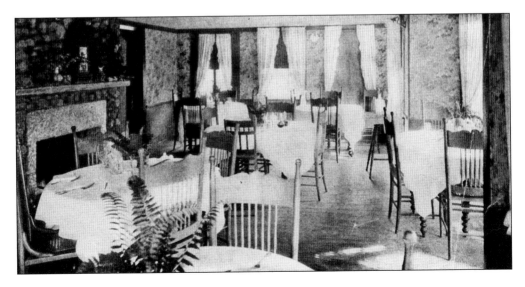

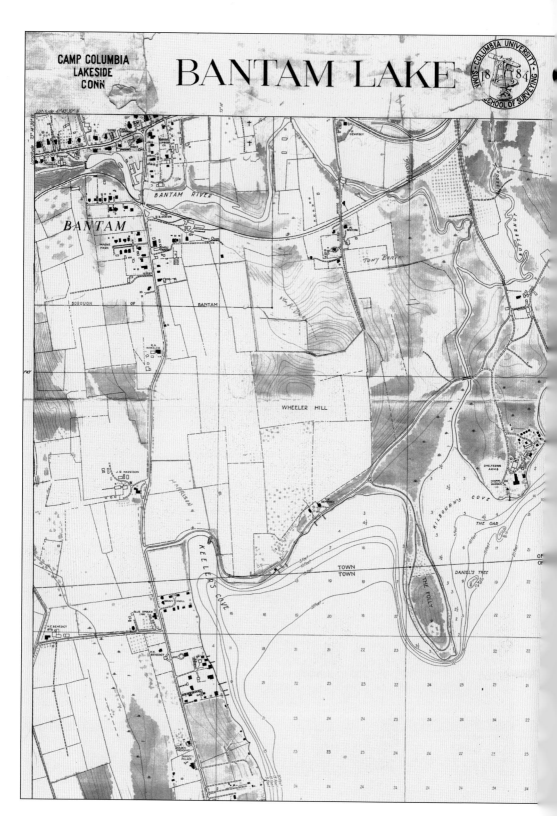

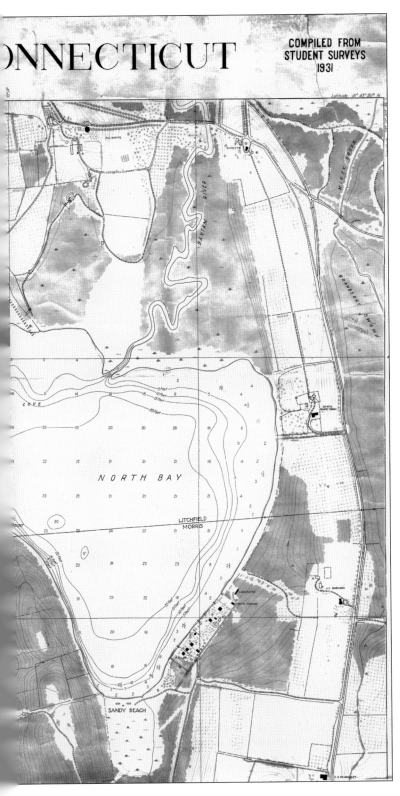

COMPILED FROM
STUDENT SURVEYS
1931

This map shows North Bay, one of Bantam Lake's three large bays, and it contains a wealth of historical information. It was compiled in 1931 from the surveys of engineering students at Columbia University, which ran a camp at the southern end of the lake. It clearly shows the Bantam River flowing in from the north and flowing out to the northwest. It shows Sandy Beach, Marsh Point, the Folly (now Point Folly), and the Sheltering Arms (also known as Camp Hope and Lenox Hill Camp). It shows the State Game Farm and the Flyway over to the Litchfield-Morris Road. The regularly spaced dots represent orchards of fruit trees. It shows the names on individual cottages, including that of Seth Thomas, the clock maker after whom neighboring Thomaston was named. The rectangular building that appears under the map's title represents the Berkshire Ice Company's icehouse.

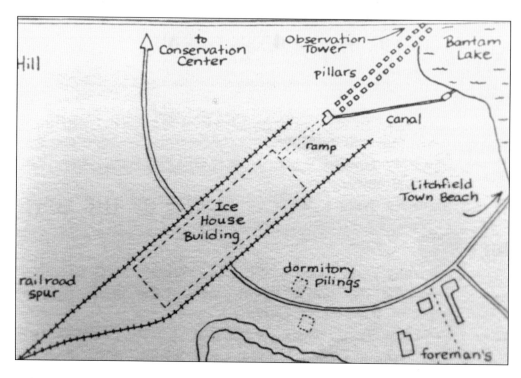

Before refrigerators, there were iceboxes, and Bantam Lake was the source of much of that ice for Litchfield residents. The Berkshire Ice Company harvested ice from the frozen surface of North Bay with an electric gang saw and loaded it onto a conveyer for storage in the icehouse. There, it was packed in hay and kept in inventory until the spring and summer. Large blocks of ice are visible on the conveyer. The ruins of the stone piers that supported the conveyer are visible today from the Litchfield Town Beach Boat Launch, as well as from White Memorial's nearby observation tower. (Above, schematic by Susan Peterson; below, courtesy of White Memorial Foundation.)

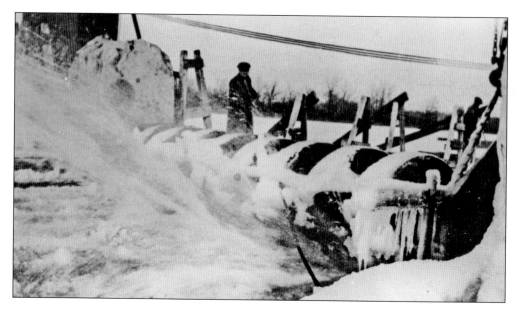

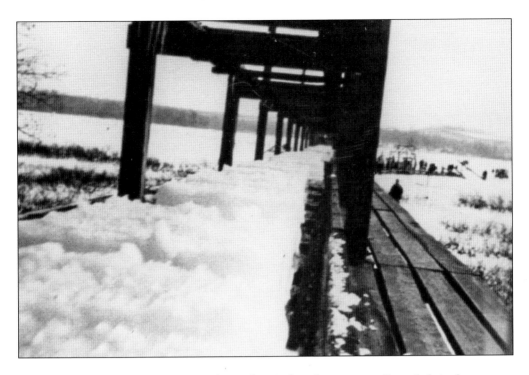

"This is the Berkshire Ice Co.," wrote Alain White, "whose long trains pull out daily in the summer, carrying concentrated relief from the Litchfield Hills to the larger cities to the southwards. Some idea of the work done by the Company on the Lake during the coldest days of the winter may be gathered from the single fact that it takes forty acres of ice, one foot in thickness, to furnish the 75,000 tons required to fill the ice-house of the Company. In the harvesting of ice, the electricity furnished by the harnessing of the Bantam Falls does the work of great bodies of men." (Both, courtesy of White Memorial Foundation.)

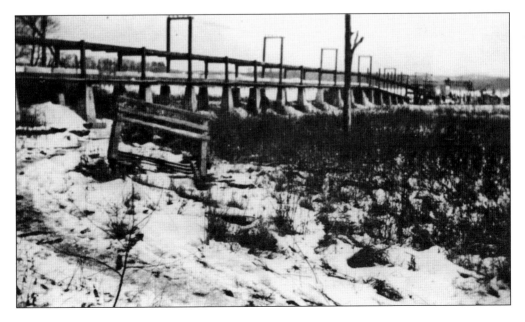

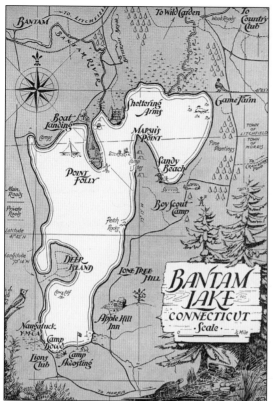

This whimsical map is from a 1938 brochure of the White Memorial Foundation. It features miniature drawings of a pheasant, a Boy Scout signaling, a sunbather, a blue jay, canoeists, water lilies, and even a snapping turtle. The reader was in no doubt that Bantam Lake was a delightful destination. (Courtesy of White Memorial Foundation.)

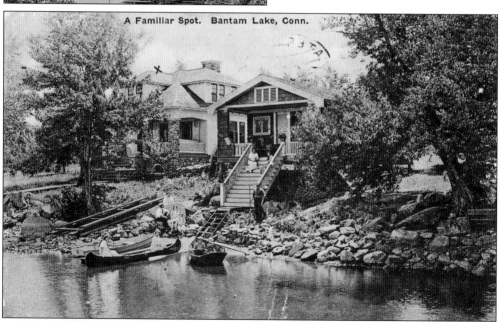

In buying up the land around Bantam Lake, Alain and May White often found themselves in possession of property with cottages. A convention evolved that the ownership of the cottages remained with the residents, who, then as now, leased the land under the cottages on a year-to-year basis. (Courtesy of the Van Winkle Family Archives.)

May White explained how Little Pond was named. "Its name harkens back to early days in Litchfield, when Bantam Lake was known only as the Great Pond, and the Little Pond was named in contrast. Its waters are surrounded by boggy swamps and there used to be a thicket of black spruce at the north end, which was destroyed by fire some years ago. . . . The stretch of the River from the Little Pond to Bantam Lake has long been a favorite with canoeists, fishermen, and motor boat parties, who can come up as far as the first bridge [motor boats are now prohibited on the river]. . . Whether one comes out at dawn to see the wildlife near the river through the morning mists, or at midday for a picnic lunch, or whether one braves the evening's mosquitoes for the sake of a moonlight party, the river is always beautiful and always fascinating." (Both, courtesy of White Memorial Foundation.)

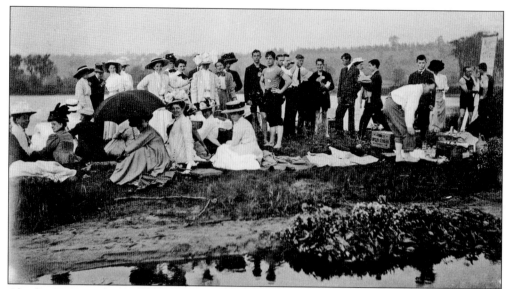

Charles H. Coit established the Canoe Club in 1898, and in 1909, Charles T. Payne began sponsoring parties and contests with processions of decorated canoes illuminated by colored lanterns. This 1909 photograph shows one such party on a sandbar at Little Pond with spectators dressed in their Sunday best. (Courtesy of White Memorial Foundation.)

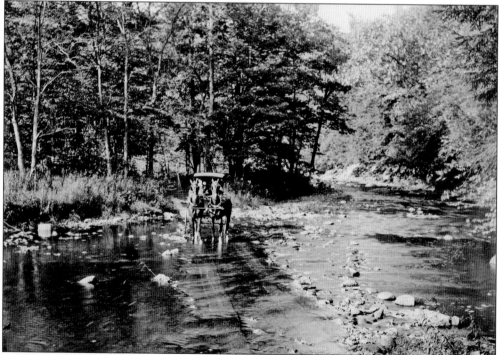

In addition to the 4,000 acres that Alain and May White donated to create the White Memorial Foundation, they also purchased and donated another 4,600 acres to preserve other scenic sites, including Macedonia Brook, Steep Rock Reservation, Mohawk Mountain, Kent Falls, and Peoples State Forest. Here, a carriage is crossing the Shepaug River at Steep Rock's double ford. (Courtesy White Memorial Foundation.)

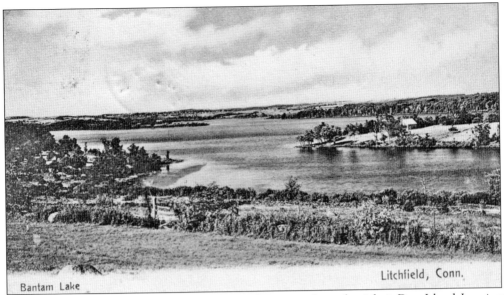

Bantam Lake

Litchfield, Conn.

This view faces northeast over Deer Island Bay. The peninsula on the right is Deer Island. Logging has cleared the trees from around the lake for firewood, agriculture, and to provide wood for the production of charcoal. This photograph is from a 1906 Karl brothers postcard, which was mailed to an address in England with a 2¢ stamp.

Located on Beaver Pond, the Nokomis Tea House was named for the Longfellow poem *Song of Hiawatha*: "By the shores of Gitchee-Gumi, by the shining big sea water, stood the wigwam of Nokomis, daughter of the moon, Nokomis." One of May White's favorite refuges, it was destroyed by vandals. (Courtesy of White Memorial Foundation.)

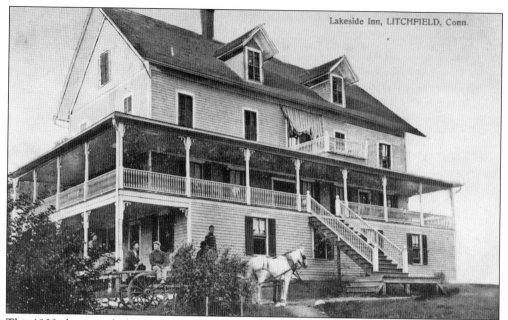

Lakeside Inn, LITCHFIELD, Conn.

This 1909 photograph shows the Lakeside Inn, built in 1896 after a fire destroyed its predecessor. At this time it was still in operation as an inn on a peninsula on Bantam Lake then called Bissell Island. It is now Lenox Hill Camp. The Whites purchased the inn in 1911 and converted it into a seasonal convalescent home for women called Sheltering Arms.

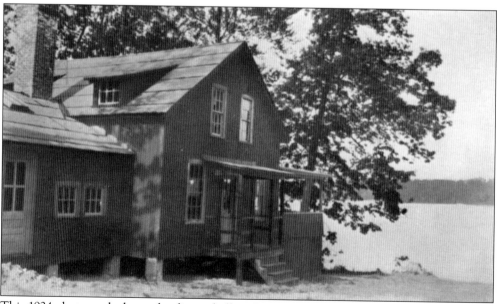

This 1924 photograph shows the dining hall at Camp Westover, which was on the west shore of Bantam Lake. The Whites were unable to purchase this property, and it was eventually developed as a residential community. The loss of placid scenes such as this one put the White's preservationist vision in perspective.

Seven

White Memorial Conservation Center

The White Memorial Foundation was established in 1913 by Alain White, portrayed here in his carriage, and his sister Margaret "May" White. They purchased 8,600 acres of land, planted one million tree seedlings, and created foundations to preserve it in its natural state in perpetuity. Residents of Litchfield, as well as visitors, will forever be in their debt. (Courtesy of White Memorial Foundation.)

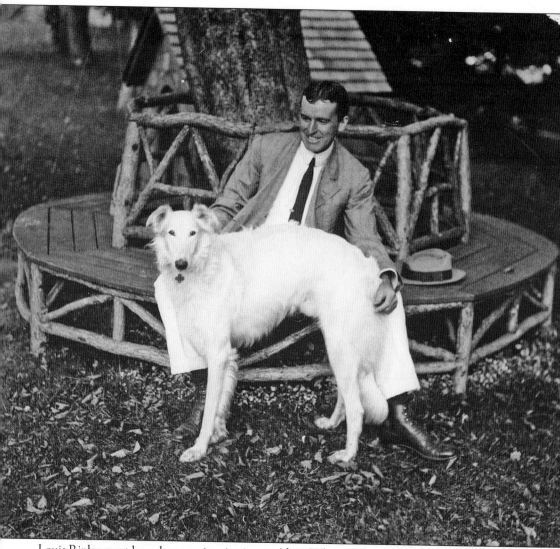

Louis Ripley must have been an inspiration to Alain White. When urbane world traveler Ripley came to visit White in 1910, bringing a completely unknown breed of dog, and one so beautiful, White was awestruck. The Romanov czars had forbid the breeding of Russian wolfhounds outside the Russian court. But with revolution in the wind, some of these dogs were spirited out of Russia. One of them, Ripley's Countess Elka, charmed Alain White 13 years before the American Kennel Club would recognize the borzoi as a breed. (Courtesy of White Memorial Foundation.)

Margaret (May) Whitlock White, sister of Alain White, was, according to F. Kingsbury Bull, "extremely attractive, really beautiful, petite, with charming manners, always thoughtful of others." She was an exceptional linguist and taught herself Russian. She was an avid theatergoer and oversaw children's performances at Whitehall. She taught Sunday school and, weather permitting, walked to church in town. May was a great lover of nature and shared the preservationist vision of Alain, 11 years her junior. When the Whites added the Lakeside Hotel to their growing inventory of contiguous properties, they converted it to a summer refuge for underprivileged children from New York City, with May serving as the organization's treasurer. May was every bit the visionary and every bit as generous as her famous brother, and she deserves equal recognition. (Courtesy of White Memorial Foundation.)

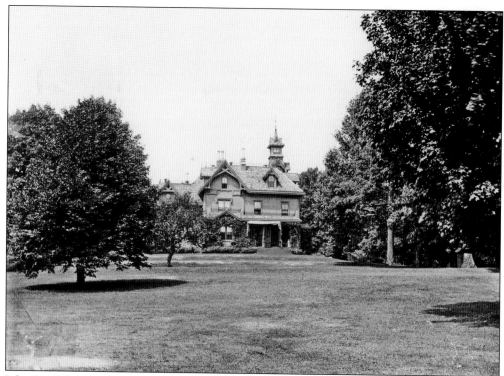

John Jay White and Louisa Laurance Wetmore were married in 1858. During the Civil War, New York City was plagued by riots protesting the military draft. The Whites, then parents of a young family, left their Fifth Avenue brownstone and moved to Litchfield. Here, in the summer of 1863, they built this beautiful cedar-shingled Victorian, which they called Whitehall. The nearby carriage house was constructed at the same time and is the last vestige of the estate's Victorian grandeur. The museum at the White Memorial Conservation Center now occupies this building, though it has been remodeled for ease of maintenance and its top floor removed. Alain White was the youngest of their six children, born March 3, 1880.

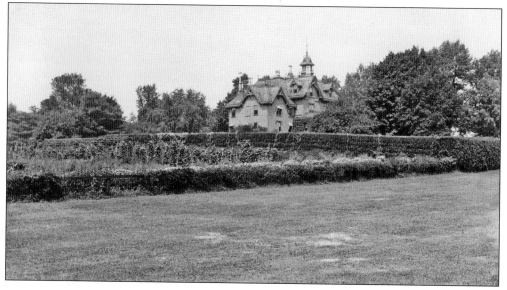

Russian wolfhounds, now known as borzoi, were bred exclusively by the Russian royal family and were owned exclusively by the Russian nobility. The Bolsheviks associated them with Russia's feudal oppression, and the dogs were slaughtered along with their owners during the revolution. Louis Ripley saved this one, Countess Elka, and brought her with him on a visit to Whitehall.

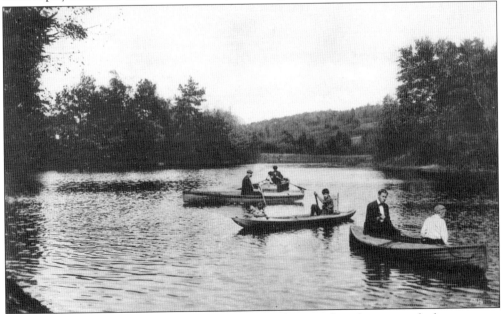

In 1910, as now, the Bantam River was popular with boaters, though it is now far less common to see gentlemen paddling in jackets and ties. This scene is on the outflow from Bantam Lake, on the millpond at the top of Bantam Falls. The canoes are made of strip cedar, and the decks are canvas.

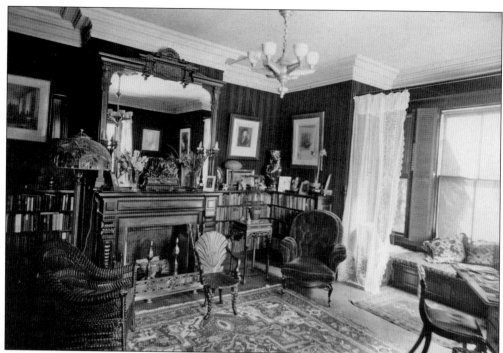

What the Whites called the "Front Library," seen in the photograph above, is now the museum's gift shop. The fireplace is now concealed behind a wall, but the crown molding on the ceiling still marks its original location. Taken at 2:39 in the afternoon, according to the mantle clock, this photograph shows a Tiffany floor lamp standing to the left of the fireplace, a portrait of George Washington hanging on the wall to the right of it, and a potted Norfolk Pine on a side table. Below, Whitehall's entrance hallway is visible in the center of this photograph, and the Tiffany lamp is now on the right. Beyond the entrance hall is the Music Room, visible in the background.

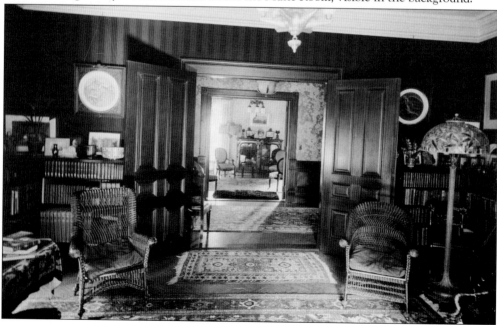

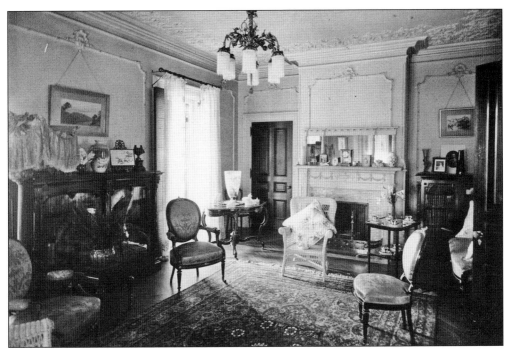

These photographs show Whitehall's Music Room (above) and dining room (below). The ceilings, doors, mantles, woodwork, and walls feature exquisite molding. The ceiling lights are surrounded by crystal drops to disperse the newly invented incandescent light, and Persian carpets cover the floors in every room. Despite being called the Music Room, no instruments are on display; actually Alain White studied chess and May was an avid reader. The table to the right of the fireplace displays a Chinese tea service and a vase with fresh lilies. With only a brother and sister living alone in the big house, the dining table (below) was modest indeed. A photograph of their father, John Jay White, hangs above the fireplace. Sunlight pouring through the windows provides the only light for these rare indoor photographs.

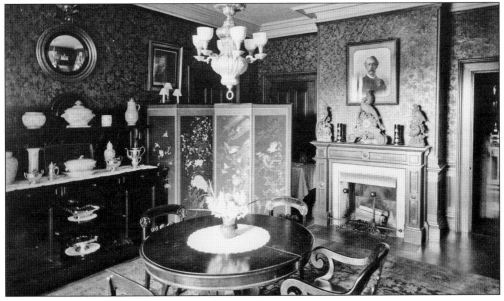

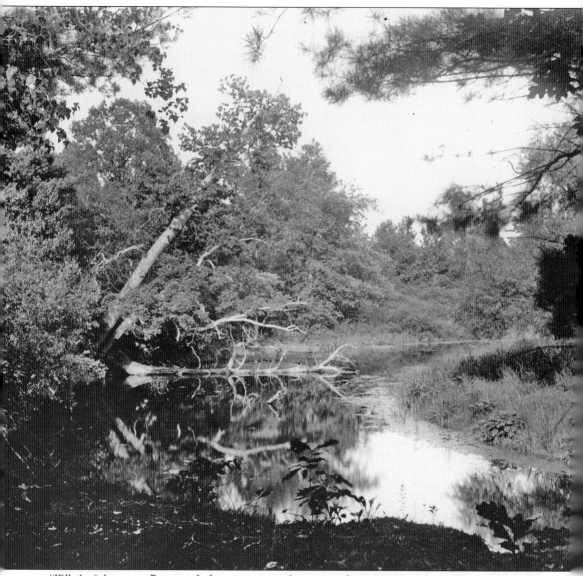

"While fishing on Bantam Lake one tranquil summer day in 1908, Alain White said to his friend William Mitchell Van Winkle, "Wouldn't it be wonderful to preserve this river, lake, and countryside as we see it now?" Van Winkle heartily agreed, and later that day Alain confided his dream to his sister May who loved the woods and waters as dearly as he. Ardent conservationists long before their time, they quietly began to purchase abandoned farms, scenic plots, waterfalls, and forested valleys and ridges around the lake. At the time, the Whites' motives were misunderstood, and it took decades for the public to recognize their monumental contribution to conservation. (Quotation and photograph courtesy of White Memorial Foundation.)

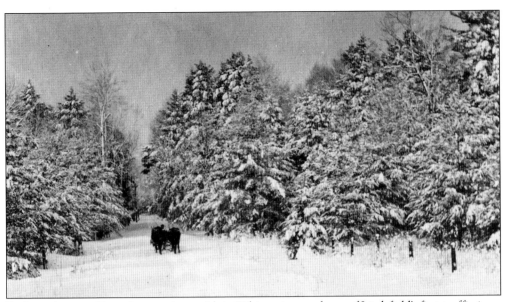

Early in the era of horseless carriages, Alain White witnessed one of Litchfield's first traffic jams as two of these contraptions attempted to pass one another on the single-lane carriage path in front of Whitehall. His solution: build a new, wider road to detour traffic from his doorstep. He called the new road New Road; it is now called Bissell Road. The above photograph shows an ox-drawn sleigh traversing New (Bissell) Road in winter. The photograph below depicts a horseless carriage emerging from the old road, having just passed by Whitehall. One look at the narrow tires makes it obvious why horse and ox power continued to provide winter transportation long after the invention of the automobile. (Both, courtesy of White Memorial Foundation.)

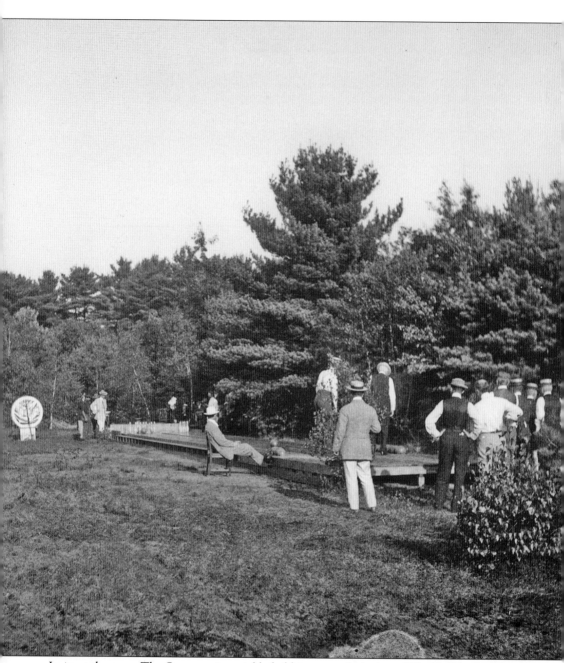

In its early years, The Sanctum invariably held its annual picnic at White's Woods. This 1910 photograph shows an elevated, outdoor bowling alley. Picnic or not, the dress code is jackets and ties for these Sanctum members as they enjoy a game a duckpin. When they tire of bowling, an archery target is available for a diversion. Alain White himself, wearing a light suit and white hat, reclines in a straight-backed chair to police the lane's foul line. It was a remarkable feat of engineering to construct a perfectly level bowling lane on the uneven ground, and to do it for a one-day event reflected great dedication to the cause of fellowship.

116

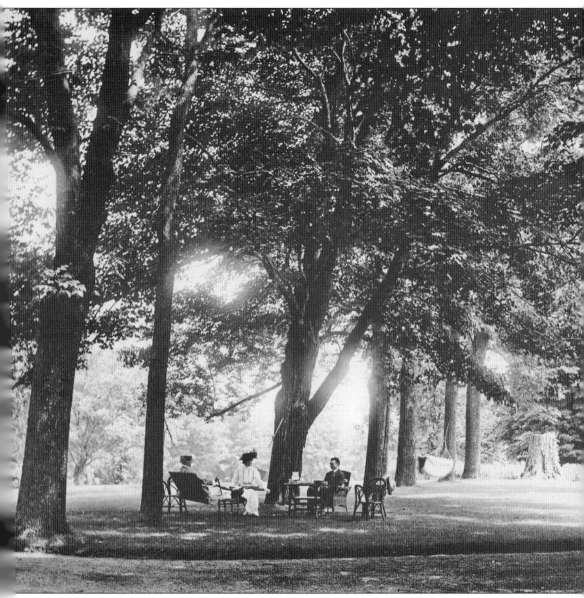

It is 1908. From left to right, Alain, May, and a fellow Sanctum member and the Bantam River Country Club founder, Seymour Cunningham, are in repose on the front lawn of Whitehall. The gentlemen are in jackets and ties, and May is equally decked out. It may have been a life of privilege, but it was Alain and May's vision that every generation following them would enjoy this same privilege. Visitors are welcome to sling their own hammocks and bring their own iced tea. Whether dressed formally or casually, everyone can now enjoy nature's blessing thanks to the Whites' vision and generosity. The large tree trunk on the right of the photograph is still out in front of the White Memorial Museum. The monstrous ash and maple trees are long gone, but that one large stump has been curiously durable. A visit to the museum will resolve the riddle.

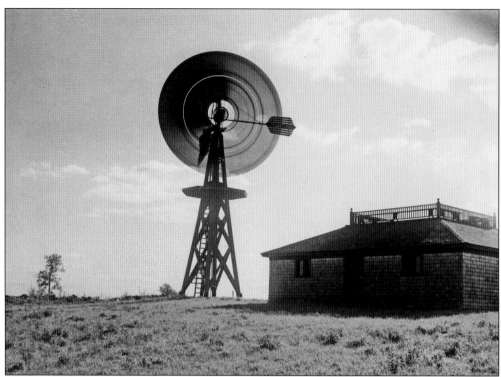

This windmill is now long gone, replaced by an expanse of pine forest, though the name, Windmill Hill, preserves its memory. This windmill pumped water into a roofed cistern, which provided natural water pressure for Whitehall, 400 yards downhill. This hill is now part of a vast pine forest. The Whites presided over a planting program for one million trees. In the distance of the photograph below is Bantam Lake and Marsh Point. The camp building depicted is no longer standing. (Both, courtesy of White Memorial Foundation.)

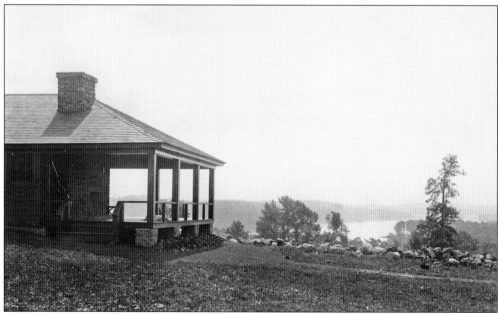

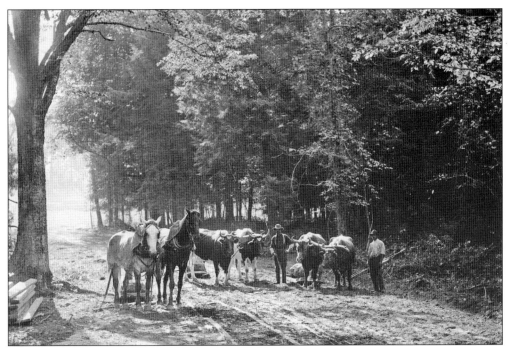

This striking 1908 photograph, taken by Alain White, depicts the logistics of a road-grading crew in the days before heavy equipment. Each team is hitched to a sledge, and each sledge carries one large boulder. The newly constructed road is having its surface smoothed out. Once a road became rutted from carriage traffic, it would be smoothed out again the same way.

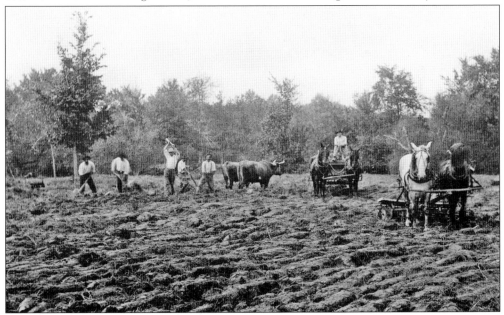

Taken in 1910, this photograph depicts the same white and black horse team seen above, this time harrowing the fields. Laborers with pickaxes are dislodging stones and cutting out roots. The Whites tried to grow as much of the produce consumed at Whitehall as possible. (Courtesy of White Memorial Foundation.)

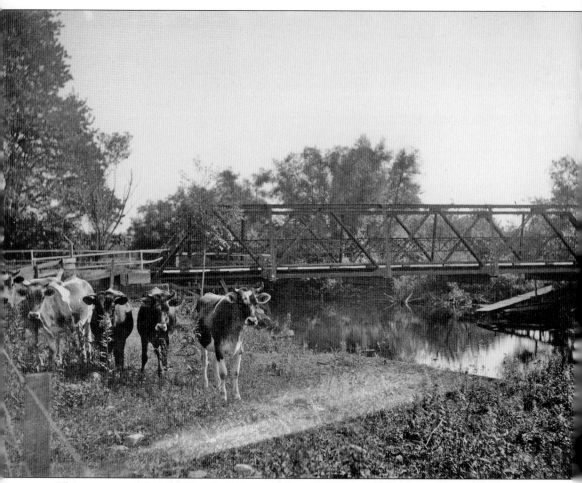

This scene was labeled "Whitehall Sentinels" in the Whites' 1909 photo album. The location is Chickadee Bridge, also known as the Silver Bridge. It is the first bridge a canoeist reaches when coming upstream from Bantam Lake, and May White refers to it as the farthest up the Bantam River that a motorboat was permitted. The launching ramp on the far side of the bridge is no longer there. Entrants in the Litchfield Hills Road Race will recognize this landmark, as the course passes over it just before the four-mile mark. Given the direction of the light (the river runs southerly here), the Whites took this photograph on an early-morning walk. The riverbank in the foreground is now crowded with vegetation, and the willows on the far bank have fallen. During very cold winters with very little snow, it is possible to ice skate from this point to Bantam Lake and back. (Courtesy of White Memorial Foundation.)

This 1952 trail map shows some of White Memorial's main attractions: Bantam Lake, Beaver Pond, Little Pond, Sandy Beach, the Wild Flower Garden, and the Litchfield Country Club. Alain White was the club's first president after relocating to this location in 1921. Biglow Pond, shown to the right of Route 61 (now Route 63), was the mill pond for generations of Marsh and Biglow family enterprises. It was dynamited by the Army Corps of Engineers three years after this map was published to return the river to its natural flow. This map is nearly 60 years old and should not be relied upon as a guide for walking tours.

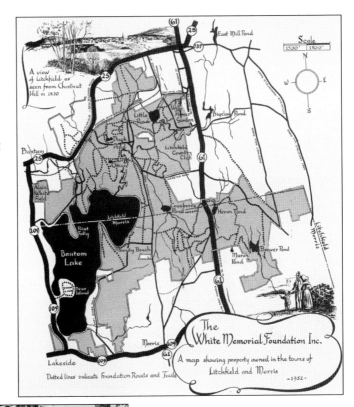

The photograph at left depicts Beaver Pond, where the Whites' built the retreat they called Nokomis Tea House. The Whites also harvested ice from Beaver Pond in the winter. May White scoffed at the notion that beavers ever lived here. (Courtesy of White Memorial Foundation.)

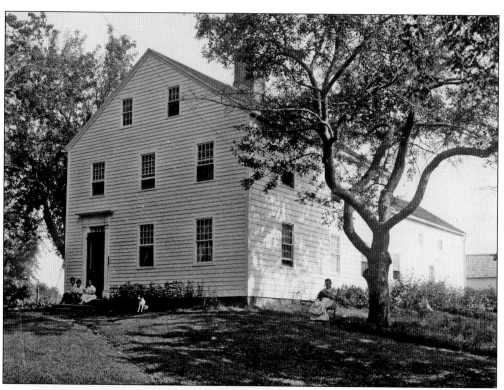

Alain and May White's three photo albums, collectively known as the "Whitehall Books," represent the years 1908, 1909, and 1910. The Whites were skilled photographers, and they trained their camera on a multitude of subjects, among them the Donahue Cottage (above) and Eamon's Place (left). The locations of both of these dwellings are lost to time. (Both, courtesy of White Memorial Foundation.)

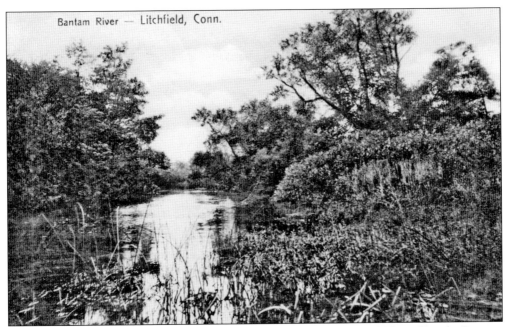

Bantam River — Litchfield, Conn.

"The Foundation tract is fortunate in its ponds and streams," wrote May White. "Besides Bantam Lake, there are five ponds, Little Pond, Cranberry Pond, Duck Pond, Beaver Pond, and Heron Pond, built in 1916, and named for the small blue herons which are often seen wading along the banks in search of a fish supper." (Courtesy of White Memorial Foundation.)

Arthur Catlin, shown in this 1910 photograph, owned the Catlin Farm, which the Whites acquired and added to the land that became the White Memorial Foundation. Catlin's 1853 Colonial Revival farmhouse now serves as the clubhouse of the Litchfield Country Club, and his meadows are now fairways. (Courtesy of White Memorial Foundation.)

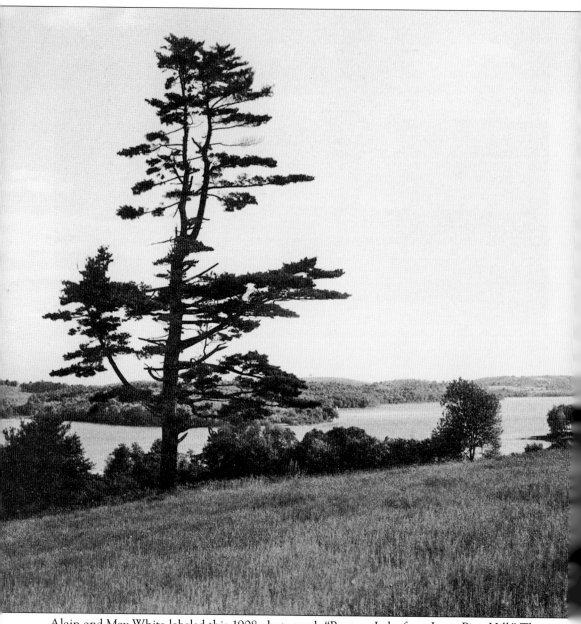

Alain and May White labeled this 1908 photograph "Bantam Lake from Lone Pine Hill." This site is clearly depicted in the sketch of Bantam Lake at the top of page 102 of this book. The peninsula in the background is Deer Island. This photograph was taken by the Whites in their exploration of the lake for potential properties to acquire, though this one eluded them. If the Whites had managed to acquire this land, it would look the same today as it did in 1908. (Courtesy of White Memorial Foundation.)

The Donahue children, whose home is visible in the background above, are out of school for the summer. The photograph of their classroom, below, hints at the teacher's lesson plan. There is a map of Maine on the far wall. The stove is cold and decorative paper chains hang from the ceiling. A wall map of the United States hangs on the far right. The teacher's desk is stocked with the tools of her trade—a bell to ring the class to order, an inkwell with its quill still protruding, and three stout willow switches. (Both, courtesy of White Memorial Foundation.)

This 1929 photograph was taken at Topsmead by Edith Morton Chase. It depicts the type of carriage used recreationally around Topsmead and on the carriage paths at White Memorial Foundation. Edith Chase had a Packard automobile and a chauffeur, but on nice days, the carriage would have been irresistible. (Courtesy of Connecticut DEP, Topsmead State Forest.)

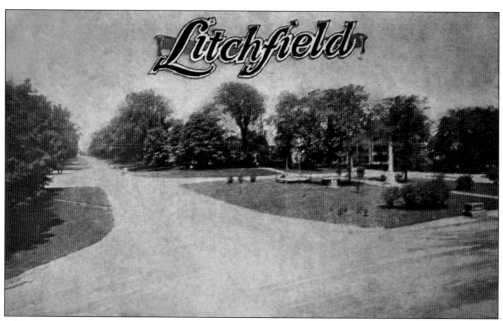

This photograph is from the inside lid of a 1917 box of Litchfield Cigars, produced by E. Morgan & Bro., Waterbury, Connecticut. The photograph was taken from a window in the old courthouse. The watering trough on the right is now used as a flower planter at the west end of the West Park. The raised platform next to the cannon is for the Fourth of July celebration.

INDEX

DISCOVER THOUSANDS OF LOCAL HISTORY BOOKS FEATURING MILLIONS OF VINTAGE IMAGES

Arcadia Publishing, the leading local history publisher in the United States, is committed to making history accessible and meaningful through publishing books that celebrate and preserve the heritage of America's people and places.

Find more books like this at
www.arcadiapublishing.com

Search for your hometown history, your old stomping grounds, and even your favorite sports team.

Consistent with our mission to preserve history on a local level, this book was printed in South Carolina on American-made paper and manufactured entirely in the United States. Products carrying the accredited Forest Stewardship Council (FSC) label are printed on 100 percent FSC-certified paper.

MADE IN THE